IMAGES
of America

CENTERVILLE

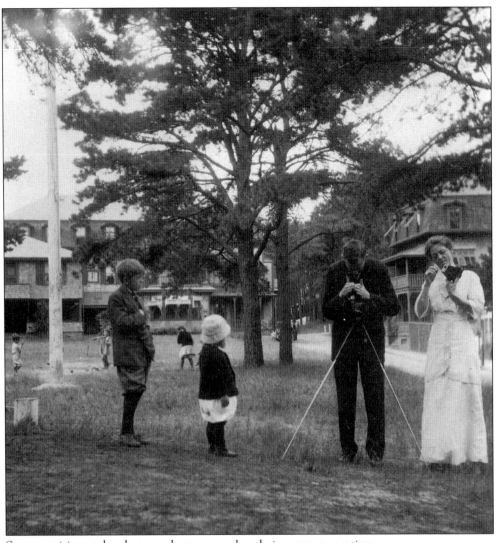

Summer visitors take photographs to remember their summer vacation.

IMAGES
of America

CENTERVILLE

Britt Steen Zuniga

ARCADIA

First printed in 2001.

Published by Arcadia Publishing,
an imprint of Tempus Publishing, Inc.
2A Cumberland Street
Charleston, SC 29401

Printed in Great Britain.

Library of Congress Catalog Card Number: 2001088721

For all general information contact Arcadia Publishing at:
Telephone 843-853-2070
Fax 843-853-0044
E-Mail sales@arcadiapublishing.com

For customer service and orders:
Toll-Free 1-888-313-2665

Visit us on the internet at http://www.arcadiapublishing.com

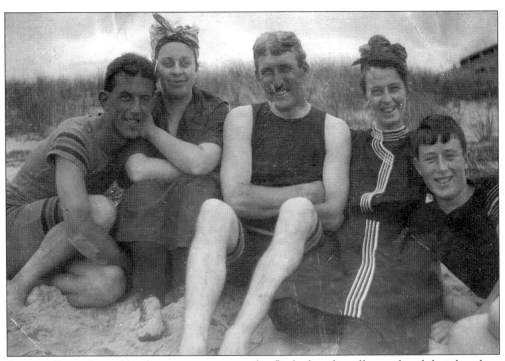

Centerville residents, like the summer tourists who flocked to the village, adored their beaches. This photograph from the late 1890s shows, from left to right, Howard Lumbert, Ella Hallett, Frank and Eunice Crocker, and an unidentified gentleman enjoying the lighthearted days of summer.

CONTENTS

The mission of the Centerville Historical Society shall be
"To preserve and share the unique history of the people of Centerville,
inspiring a sense of community and appreciation of our Cape Cod heritage."

ACKNOWLEDGMENTS

There are a number of individuals whom I would like to thank for their assistance in the completion of this book. Jennifer Longley was a willing test market for the book, and her comments, suggestions, and insights were both invaluable and greatly appreciated. I would also like to thank Dr. Charles Herberger and Elna Nelson for the time they spent proofreading the manuscript. Their exhaustive knowledge concerning the history of the village served as an important resource in assuring historical accuracy. There were many individuals and organizations that lent photographs who are credited in the book but whom I would like to thank here: Melvina Herberger, Vivian Nault, Sam Nickerson, Margaret Foster, Lt. Britt Crosby, and the Craigville Camp Meeting Association. I would be remiss not to thank the board of the Centerville Historical Museum who supported this project from the beginning and encouraged me to move forward. Lastly, I would like to thank all those early Crosbys, Kelleys, Bearses, Marstons, Nickersons, Phinneys, Halletts, and other Cape Cod families for making this village and all the villages on Cape Cod such fascinating places to study.

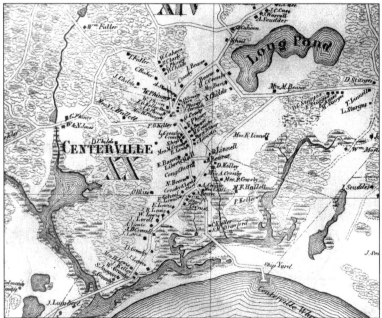

This 1856 map shows the locations of homes in Centerville.

INTRODUCTION

One of the most beautiful and fertile of the seven villages in the town of Barnstable, Centerville has roots that go back to the mid-17th century, when it was called Chequaquet, the Native American name for "pleasant harbor," or "pleasant cove." The area of land that Chequaquet occupied was part of the 1648 purchase from Sachem Paupmumuck of the Wampanoag tribe by Myles Standish for two brass kettles and some fencing. Soon after the purchase, the portion of land that Chequaquet occupied was selected for settlement.

There was not much of a community prior to 1800. The early-18th-century settlers located themselves near Wequaquet Lake, where there was fertile soil as well as access to fresh water and fish. The beginning of the 19th century, however, saw dramatic expansion and growth. In 1834, when the first post office was established, Chequaquet was renamed "Centreville." Centerville received its modern spelling when Pres. Theodore Roosevelt implemented Americanized spelling in the early 1900s.

Centerville was aptly named for its central location among the villages in the town of Barnstable. As such, it held a unique position in the town, as it was both crossroads and meeting place. The first Centerville Town House was built on Oak Street, which is the approximate geographical center of the town of Barnstable. Prior to modern conveniences, the trek to the town house to cast your vote could be a long one. Even Centerville residents living on Main Street had a two-mile walk each way. Despite this, the Oak Street location served as the town hall until 1926.

In the early 19th century, a number of enterprising young men started a variety of businesses to provide all the necessities, although most food and clothing were produced in the home. Physicians, cigar makers, poets, taxidermists, wheelwrights, masons, sea captains, merchants, apothecaries, leather makers, and blacksmiths all made their living in this village by the sea. Whether they were tillers of the soil or toilers on the sea, they made the 1840s through the 1860s the heyday of Centerville's economic development. A number of commercial enterprises created Centerville's economic backbone. They were the saltworks, the shipyards, and cranberry farming.

In the Skunknet area of Centerville, huge earthen pits shaped like doughnuts were dug as coaling pits. These were sites where charcoal was once made for later use in the smelting of bog iron ore in the foundries of Barnstable. The production of lime, created from the burning of clam and oyster shells and also used in the production of iron, was also a Centerville enterprise.

In the 1820s and 1830s, Centerville's maritime economy established itself as a dominant force, and settlement patterns moved south from the lake and pushed closer to the shoreline. Between the years 1815 and 1860, Centerville ships and their shipmasters attained great renown for their seafaring ability and financial acumen. One of Centerville's best-known sea

captains is Josiah Richardson, who gained international fame sailing Donald McKay's clipper ships and setting records for his voyages between the East and West Coasts.

The Civil War had a profound impact on maritime trade in all of New England. Confederate ports were completely shut off, and all along the Atlantic coast Confederate privateers preyed heavily on merchant ships. Other factors, in conjunction with the war, impacted the maritime trade with devastating consequences. The growth of railroads, the development of steam power, changing markets, the "freeze" of 1871 in which many Cape Cod vessels were lost in the crush of ice, and the diminishing supply of lumber and the lack of capital available in the post–Civil War era to build ships all combined to signal the demise of the maritime trade for Centerville, as well as much of New England.

By the 1890s and early 1900s, the development of Centerville as a summer resort began to play a greater role in its economy. A number of its native sons who had left to seek better business opportunities in Boston and out west returned in the summer with their families, creating, in a sense, a family reunion each year.

The village's history is intertwined with the lives of a great number of individuals who developed Centerville's business economy while at the same time serving her civic needs with undeterred resolution. For its entire history, Centerville has been proudly maintained by its residents. As important is the sense of responsibility that many of the village's residents feel in the preservation of its rich history. In 1904, Julia Phinney, historian for the Old Home Week celebration, stated, "If I can awaken . . . a general concern as to the importance of guarding and preserving all material of local history connected with this village, or the inhabitants thereof, I shall feel repaid." She was among the first to recognize the importance of safeguarding the village's history. Her legacy has been fulfilled by equally dedicated residents like Dorothy Waterhouse, one of the founders of the Centerville Historical Museum, Elna Nelson and Dr. Charles Herberger, among others, who have spent the better part of their lives preserving, promoting, and sharing the history of the village.

—Britt Steen Zuniga

One

THE VILLAGE EMERGES

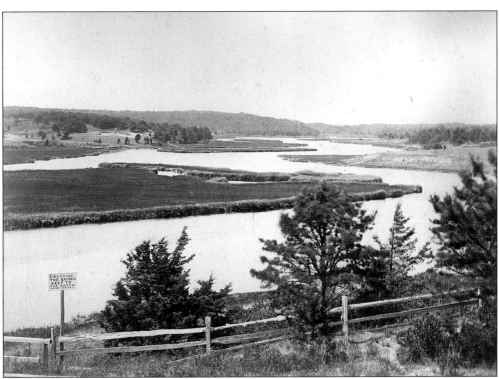

In the 17th and early 18th century, before the individual villages in the town of Barnstable were given separate distinction, the town was separated into the East and West Parishes. Oyster River, located in what would become Centerville, was the dividing line. The river, also known as Bumps River, was named after Samuel Bumpas, whose house and farm were out this way by the cedar swamp in the 1700s. As can be seen here, the geography of Centerville is characterized by picturesque variety. Hills and lowlands are complemented by meandering waterways that bisect marshes, cedar swamps, forests, and bogs—all leading to the salty waters of Nantucket Sound or the fresh waters of her many ponds and lakes.

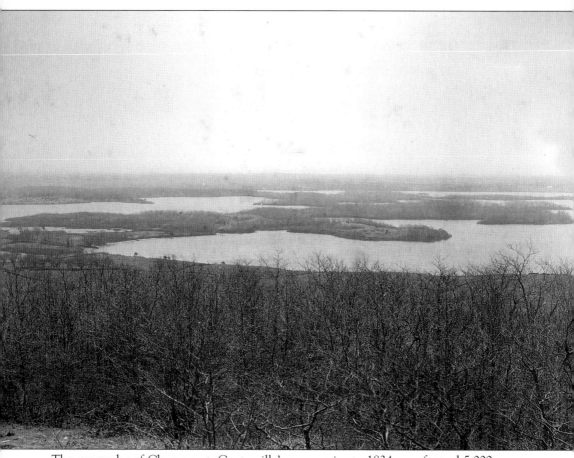

The geography of Chequaquet, Centerville's name prior to 1834, was formed 5,000 years ago when the Wisconsin glacier receded. Ice blocks buried in the sand and clay melted and became kettle holes, resulting in numerous ponds and lakes. The largest lake in the town of Barnstable,

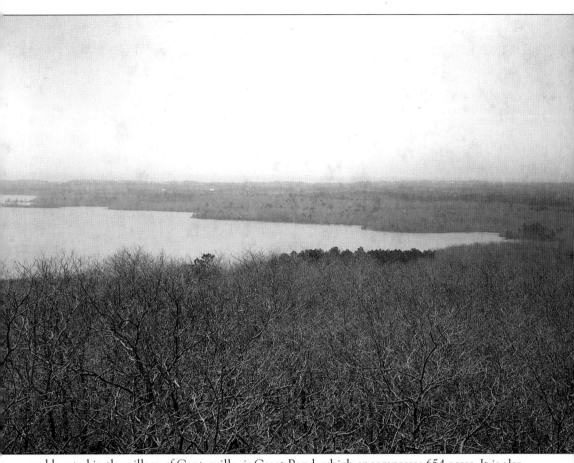

and located in the village of Centerville, is Great Pond, which encompasses 654 acres. It is also known as Cooper's Pond, Iyanough's Pond, Great Nine Mile Pond, Nine Mile Pond, and Wequaquet Lake.

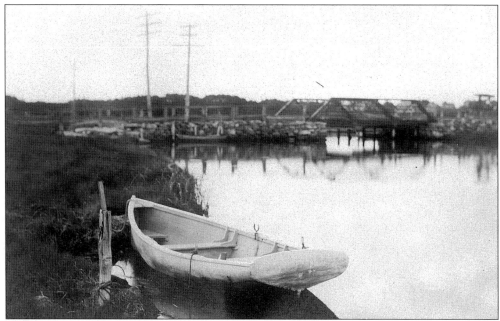

In the late 19th century, one villager remarked, "You good people who live up the street miss many of the events that occur on the beach and the river." The Centerville River, which skirts the southern border of the village and runs parallel to the barrier beach, which separates it from Centerville Harbor, was originally much narrower and lined by gigantic cedars. It was the center of fun for villagers—in the winter, when it was frozen over, it was used for horse and sleigh races and, in the summer, it was a favored spot for swimming, sailing, rowing, and fishing.

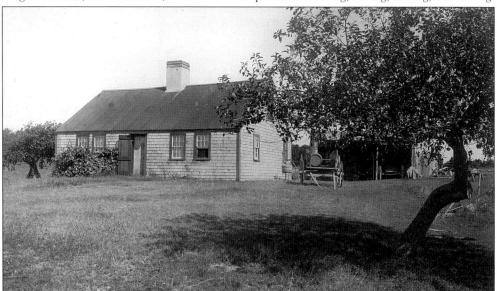

The earliest houses were built in the northern end of the village near Great Pond, as the area offered fresh drinking water for people and livestock, fertile land for farming, and a bountiful supply of fish. This house, which remains on its original site on Farm Hill Road off Phinney's Lane, was built in 1717 by "Uncle Gallison," a navigator who taught many Centerville boys navigation. It is one of the two oldest houses in Centerville.

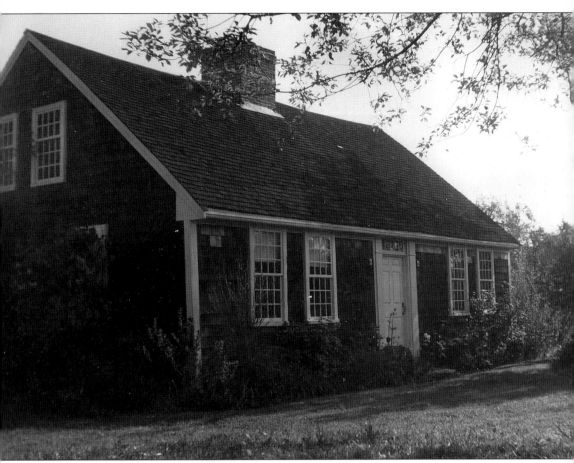

Austin Bearse, one of Centerville's first deepwater captains, emigrated from England in 1638 and settled in Barnstable. In 1639, he married a Wampanoag Indian princess and they built this home. The house has been dated to 1639 from a coin located in its timbers, a common practice in Colonial home building. Written in chalk on one of the ceiling timbers are the initials and date "E.B. 1692." The initials are believed to be those of Bearse's grandson Ebenezer, who would have been around six or seven years old at the time. In 1719, the house was moved to its present site on Church Hill Road, behind the South Congregational Church on Main Street. The original full five-bay cottage underwent subsequent additions throughout the 18th century and is the oldest surviving structure in Centerville. Bearse was an abolitionist. His hand was scarred with the brand "SS" for "slave stealer" after he brought a female slave and her children north from Pensacola, Florida.

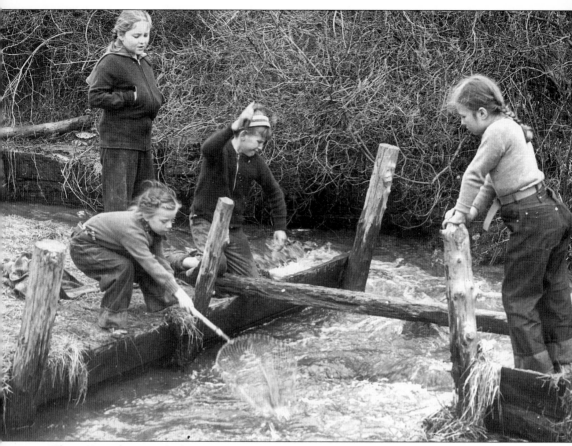

This 1970s photograph shows a portion of the early-17th-century ditch that connected Long Pond with the sea and was dug near what is now Pine Street. Records indicate that the ditch was dug with wooden shovels with iron rims and it is primary evidence for early settlement in what was then known as Chequaquet. Herring was extremely vital to the early settlers, as it was used both for food and for fertilizer. It was such an important commodity, in fact, that regulations were passed to prohibit the operation of gristmills and sawmills during the annual spring run of these fish. In 1867, the herring run was expanded and a fishery was established under the name of Nine Mile Pond Fishing Company. Dug by unemployed veterans of the Civil War, using horses and oxen, it had a combined length of nearly a mile and connected the Centerville River to Long Pond and Great Pond. It was backbreaking work and a tremendous undertaking, as its banks were 30 feet high in places. (Courtesy Town of Barnstable Chamber of Commerce.)

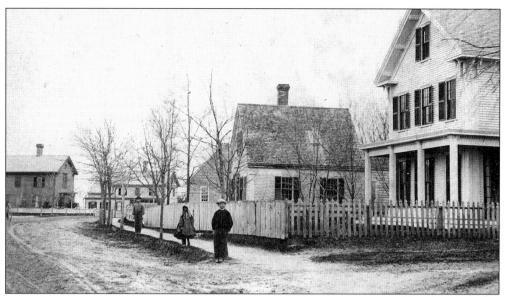

In the early 18th century, settlement patterns began to shift south to Main Street as seafaring became the predominant source of income. As late as 1820, the village had a decidedly rural appearance. Main Street was a narrow road that went through several enclosures, with the boundaries of each resident's possessions marked by gates and bars. There were 13 such divisions between the post office and the intersection of Main Street and Craigville Beach Road. Looking north toward the general store, this view of Main Street reveals the sparseness of vegetation that was characteristic of the area at this time. By 1883, the village's population was 402 and, by 1897, Centerville had established a true center with the church, library, and Howard Hall, forming the nucleus of the village's moral, intellectual, and creative existence.

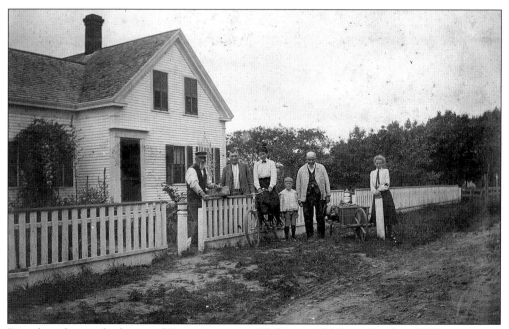

Friends gather at the house of Capt. Augustine Childs on Old Stage Road in 1855.

15

This view of what is called Craigville Beach Road provides a good mid-century view of Centerville Harbor, originally called New Harbor, which is part of Nantucket Sound. The protected harbor provided a bountiful supply of fish, and a skilled fisherman could make $12 a day. In 1850, more than 200 catboats were recorded trolling for bluefish. Early-17th-century records show that the land was covered by immense forests. These extended to the water's edge, broken only by the planting fields of the native Wampanoags and clearings made by early settlers who took advantage of the forest wealth. The forests offered the raw materials to build homes, fuel fireplaces, build ships, use as export to European ports, and serve as fuel for saltworks. By the 1840s, much of Centerville's wooded terrain had been cut down.

This view, taken c. 1850 from the roof of the South Congregational Church, overlooks the undulating and cultivated landscape of the southern portion of the village. (Courtesy Margaret Foster.)

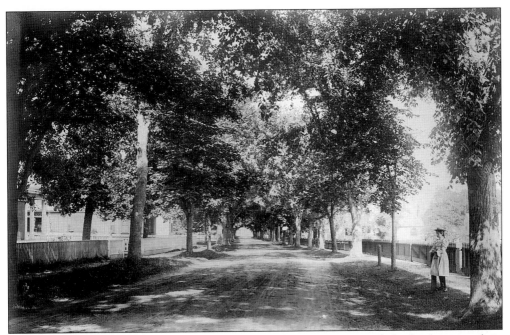

Residents lamented the loss of the beautiful trees that once canopied the landscape and, in 1850, Ferdinand Kelley took up a subscription to plant young elms along Main Street. Gorham Crosby supplied the trees, and his two sons, Gorham and Aaron, planted them. Although many of the original elms were destroyed by hurricanes, the most devastating blow was the arrival of Dutch elm disease, which claimed nearly 1,000 trees in the village between 1956 and 1974.

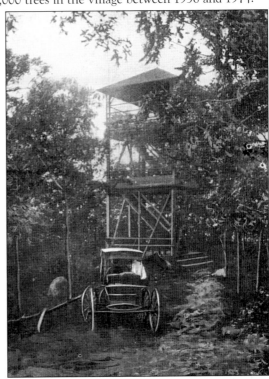

In 1897, a wooden observation tower was constructed on Shoot Flying Hill in the neighboring village of West Barnstable, so named because it was built on the site where the native Wampanoags used to shoot ducks in flight over the hill. The wooden structure, which provided a stunning view of Wequaquet Lake, was replaced by a steel tower in 1914. The tower, which was now used for spotting fires, was moved to Clay Hill in 1947 to make way for the mid-Cape highway (Route 6), which was begun in the 1950s.

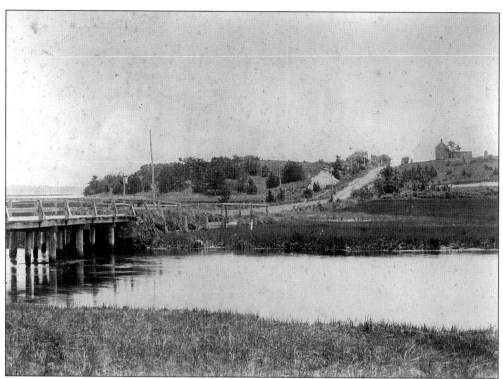

In 1842, a bridge spanning the Bumps River was built to enable greater ease in travel between Centerville and Osterville. Prior to this, villagers who wanted to travel between the two locations had to make a lengthy journey north in order to cross above the river's origin. The handwritten note below details some of the costs involved in the construction of the bridge.

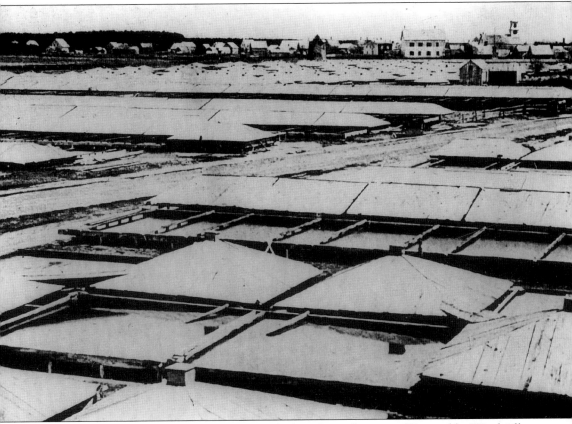

By 1808, there were a half million square feet of saltworks in the town of Barnstable. Windmills pumped saltwater between vats and were left to evaporate on sunny days. Large coverings were slid over the vats during rain. The Centerville Saltworks were located in the southern section of the village, down by the Centerville River near Clay Hill. It was managed by Capt. Edward Lewis. Before the use of solar evaporation in the 19th century, seawater was pumped from the ocean under the river through hollowed-out logs and boiled down in iron kettles. This consumed vast amounts of wood and was responsible for part of the early deforestation of the village. Salt was used to cure and preserve the fish that was eaten by crews on their sea voyages and traded in local and foreign markets. The salt industry almost entirely ceased to exist by 1850, and it is believed that this photograph dates to 1848 or 1849. In this view looking east, the steeple of the South Congregational Church can be seen in the distance.

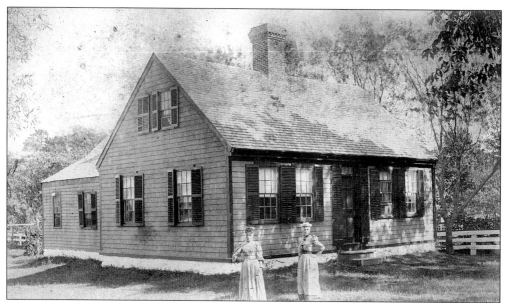

"Buttercup Cottage," the original home of Gorham Crosby, innkeeper, cranberry farmer, and stagecoach driver, is typical of the charming cottages that are interspersed between the dignified sea captains' homes on Main Street. Built in 1834, it was moved to its present site in 1856, when Crosby needed to build a larger house due to the increasing popularity of his inn. He sold the house to his relative Julia Smith Crosby in 1865, when her husband, Philander Crosby, was lost at sea and left her to care for six children on her own.

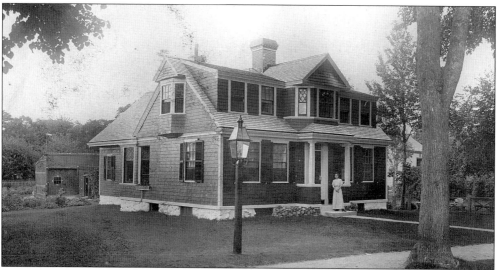

Eventually the cottage came into the possession of Alonzo Crosby, Julia's son. The cottage, which underwent major alterations in 1908, was given its quaint name when Alonzo, whose favorite flower was the buttercup, had it painted yellow. The cottage, seen here dramatically transformed from when it was the home and inn of Gorham Crosby, could stand as a symbol of the village. Owned by one of the village's foremost businessmen and passed down through the family, it was both a home and business that was constantly evolving. Buttercup Cottage represents Centerville's economic transformation, its maritime heritage, and the lineage of one of the village's founding families.

Two

DOWN TO THE
SEA IN SHIPS

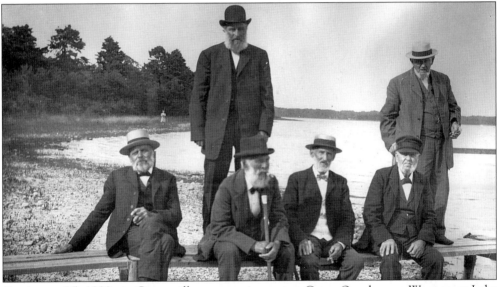

On August 25, 1908, six Centerville sea captains met at Camp Opechee on Wequaquet Lake and posed for this memorable photograph. The image symbolizes Centerville's maritime heritage, which emerged in the early 19th century, when the sea trades assumed their dominance in the village's economy. By mid-century, at least 50 percent of the male population earned its living from coastal and overseas trade, shipbuilding, or fishing. By 1860, 105 men from Centerville had become coastal or deepwater captains. Most had gone to sea as cabin boys or cooks between the ages of 9 and 13 and retired by the time they reached their late 20s and early 30s, building homes along Centerville's Main Street and starting up businesses. There was a grim side to this risky maritime business that required only the boldest and most enterprising men to become involved. Over the course of 100 years, 25 Centerville men lost their lives at sea and five vessels left the village never to be heard from again, leaving many young women widowed and children fatherless. This enduring image of Frederick Coleman, Simeon Childs, Benjamin Childs, George Hamblin, Augustine Childs, and Dennis Sturgis attests to their endurance and the sense of kinship that existed between these men.

In 1824, this shipyard was built on the Centerville River off of Main Street. Between the years 1824 and 1860, James and Samuel Crosby and Jonathan Kelley built 34 vessels of light tonnage, primarily intended as coasting vessels to New York, Boston, Martha's Vineyard, and Nantucket. Many of these vessels were built specifically for Centerville captains. In 1852, the Centreville Wharf Company was organized and a wharf was established on the long strip of beach facing Nantucket Sound, now referred to as Craigville Beach. Thirty-two stockholders, most of them village residents, owned shares in the company. Here ships were built or moored at the section that is now the public beach. Vessels of up to 200 tons were built here, in addition to repair and outfitting services. Prior to the wharf's destruction in a storm, it was bought in two parcels at public auction in May 1879. The building was purchased for $73, and the wharf property was purchased by Gorham Crosby for $8. Crosby, who had a farm and a livery stable, used the seaweed for fertilizer and the marsh hay for bedding in his stable.

The perils of the sea trades were as varied as the men who engaged in them. Capt. Arthur Phinney, born in 1822, was commander of four vessels, including the barque the *Charles P. Mowe*. While in the Mediterranean in the 1850s, during the Crimean War, he was captured by Turkish soldiers and imprisoned. Ironically, although Phinney escaped his captors, years later in 1871 he went down with his ship off the coast of Cotuit, a stone's throw from his home. His house still stands on Park Avenue, near Monument Square.

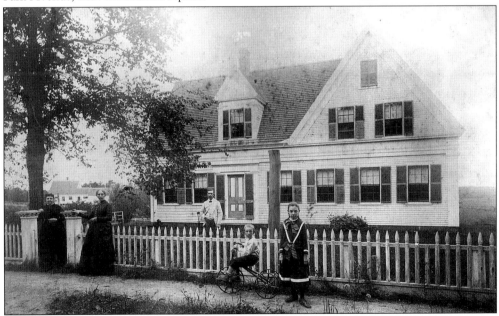

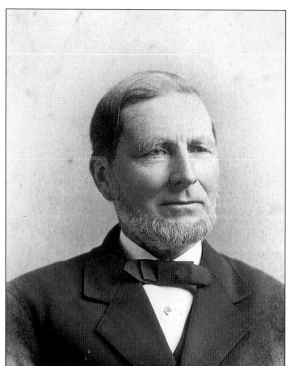

Just the opposite of his brother Arthur, Capt. Eli Phinney was known to be "as tight as the bark on a tree." Born in 1825, Eli went to sea at the age of 11. He began as a cook in a 32-ton sloop and performed every duty from cook to captain during his career. He became a deepwater captain and commanded five ships, including the *Lester B. Sherman*, over a period of 28 years, trading primarily in the West Indies and Europe. When he retired, he raised cranberries, was a member of the school committee, served as the much-feared truant officer for the Centerville Elementary School, and represented the village in the state legislature in 1876. He married Mercy Crosby, the granddaughter of Winslow Crocker, the patriarch of a prominent Yarmouth family. He and Mercy had two children.

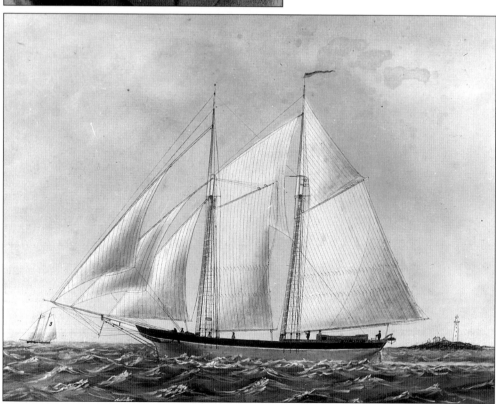

Capt. Eli Phinney's ship the *Lester B. Sherman* is shown here.

The home of Capt. Eli Phinney was built *c.* 1855 on Main Street and, although additions have been built over the last 120 years, the house still retains its historical integrity and has a commanding presence.

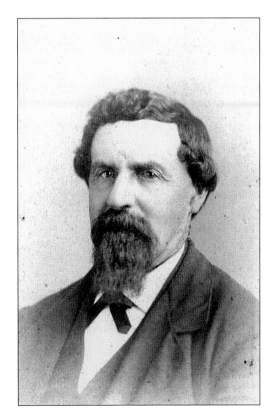

Capt. John Freeman Cornish was a highly successful coastal shipmaster who commanded the ship the *David Cox* and the *Elizabeth Cornish*, which was named after his daughter. He married Elizabeth Beals Stevens, with whom he had three children. After leaving the sea, Cornish owned a stagecoach line with Gorham Crosby. After selling the stage route, he became treasurer of the Centreville Wharf Company; as wharfinger, he collected fees from sea captains and fishermen who used the wharf. An abolitionist, Cornish was among the individuals who signed an 1850 church resolution against slavery.

The women of the village were crucial to the success of Centerville's maritime trade. While the men were out at sea, the women oversaw the finances of both the family's and their husband's business. They were both matriarch and patriarch in their husband's lengthy absences and provided peace of mind to their husbands while they were away. Elizabeth Cornish, wife of Captain Cornish, represents the strength, intelligence, and grace that characterized these women. Years later, her son-in-law Augustus D. Ayling would remark that she was "one of the sweetest characters, one of the saintliest women I have ever met," and that she provided "an ideal home where love abounded and contention was unknown."

Bizarre twists of fate were also a part of life at sea. Capt. Joseph F. Lewis engaged in coastal trade from Boston to Texas. In the winter of 1814, he was in command of the *Little Olive*. After having successfully run a British blockade with supplies for the village, the crew anchored in Centerville Harbor, disembarked, and stayed on land for the night with the plan to pull the supplies in the morning. During the night, however, the vessel was overcome by ice and dragged out to sea, never to be found. Lewis later voyaged to Africa, where he died of yellow fever.

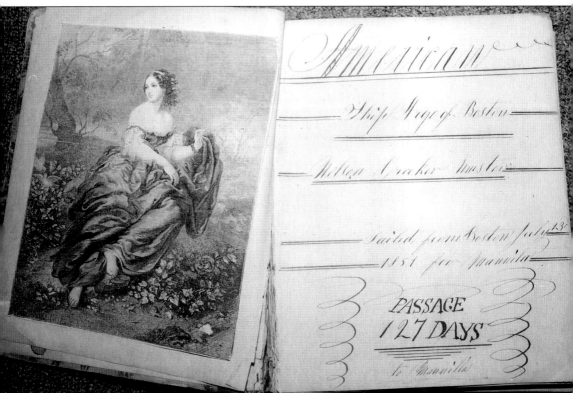

"Ship *Argo* sailed from Boston, Wednesday morning July 23, 1854 for Mannila with crew of 18 men." Thus begins the logbook of Capt. Nelson Crocker, commander of *Argo* and *Star of the East*. The log provides accounts for several voyages between the years 1851 and 1855, including the 127-day passage of the *Argo* from Boston to Manila and the voyages of the ship *Siam*, which traveled to San Francisco, Manila, and other foreign ports. In addition to providing an accounting of wages, freight and port charges, and barometric readings, the log details the experiences of Crocker and his crew. Interspersed throughout Crocker's handwritten entries are newspaper clippings, drawings of whales, pictures of fashionable young women, spiritual musings, and poetry.

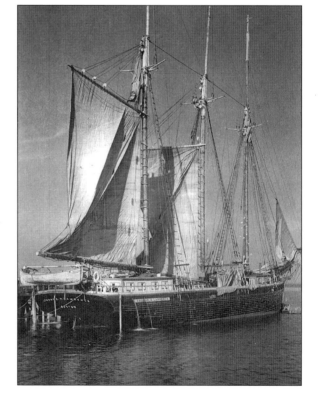

(Handwritten shareholder's agreement document, transcribed as legible:)

> We the undersigned hereby agree to take the interest set against our names with Captain Hiram H. Kelley of a Three Masted Schooner costing about $35000 = completed ready for sea. Said Vessel estimated to carry 450 tons Coal and to be sailed by the said Capt Kelley on the half share and it is further agreed that we the owners shall appoint a suitable & desirable person to be Agent of said Vessel who shall settle with Capt. Kelley each & every trip & distribute the Vessel's earnings among her owners when a sufficient amount may be in the Agents hands to make it an object to divide _____
>
> *(margin note:)* It is understood that R Crosbie & Son of East Boston are to build this Vessel & take shares to make up the estimated cost of the Vessel.

	64th
Robert Crosbie & Son	8
H. H. Kelley	8
J. Dawes	4
Holway Bros & Woodbury	2
J. Gross	2
J. W. Linnell	1
H. Hayden & Sons	1
E. W. Barrows	1
Frank W. Howe	1
Russell Marston	2
Howard Marston	2
Alvan J. Linnell	1
C. H. Lovell	1
A. S. Crosby	1
Fulston Fuller	1

In 1888, a group of shareholders contracted to have a three-masted schooner built by R. Crosbie & Son in Boston at a total cost of $35,000. This document is the owner and shareholder's agreement for the schooner *Thomas H. Lawrence*, indicating that each share was equal to 1/64 of the vessels entire worth. The list of shareholders includes well-known Centerville businessmen, such as Aaron Crosby and Russell Marston.

In 1891, the *Thomas H. Lawrence* was handed over to its first captain Hiram H. Kelley of Centerville, whose daughter Augusta Kelley (later Meigs) christened it. Named after the famous Falmouth sea captain, the *Thomas H. Lawrence* was built for northern coastal shipping and earned its reputation as the "hard luck ship" due to a series of bizarre mishaps. In 1940, the *Thomas H. Lawrence* was tied up in New Bedford after being badly damaged by a gale and, in a strange twist of fate, it was set ablaze by stray fireworks on July 4, 1941. Although the fire department saved the ship, it was pummeled by yet another storm and was ordered destroyed in late 1941.

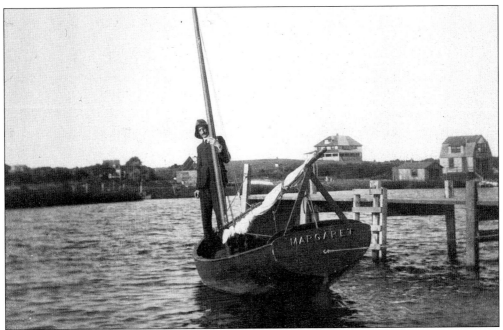

Capt. Hiram Kelley went to sea at the age of 12, became commander of a number of vessels, and was the first to command the *Thomas H. Lawrence* when it was built in 1891. He often brought his family on board the vessel, and his daughter Augusta fondly recalled that "father was a tease and loved jokes When father was searching for some lighthouse by which he guided his course, he would offer us a penny if we saw it before he did . . . we felt so excited and helpful if we found it first." In 1900, after 40 years at sea, Kelley left his calling and retired to a life of cranberry farming and fishing. Seen here in his catboat *Margaret*, he took out sailing and fishing parties for $8 per day.

Hiram Kelley's wife, Orinna, and daughter Augusta relax with friends on the lawn of their house on South Main Street.

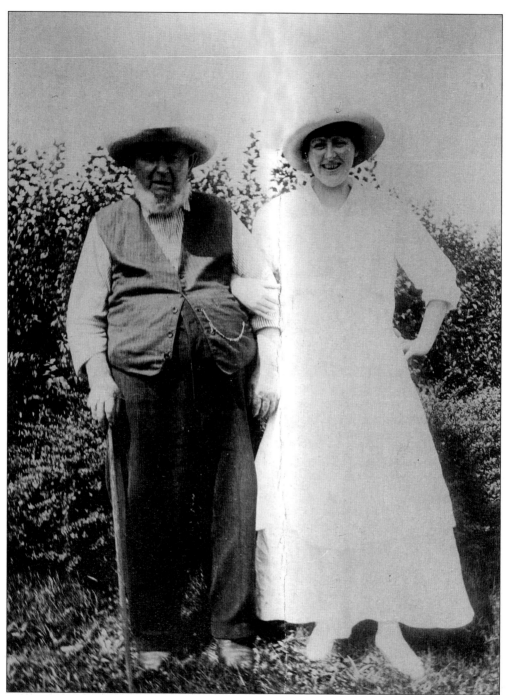

"Every other word" was what one resident used to describe Capt. Dennis Sturgis's use of profanity. Sturgis, seen here with his wife, was quite a character and proud of his resourcefulness as a captain. He once explained that he had brought a cargo of fine mahogany lumber up from Santo Domingo for Owen Bearse of Hyannis, who owned both the ship and the cargo. Sturgis found no issue with helping himself to some of the mahogany, as he had an important use for it. He needed it to build a pigsty behind his house.

Capt. Nelson Bearse was commander of the *Banner*, a Centerville-built vessel, and the *Nelson Harvey*, named for his son. He and his wife, Gloria, had 15 children. Eight of them were boys, three of whom became coastal captains.

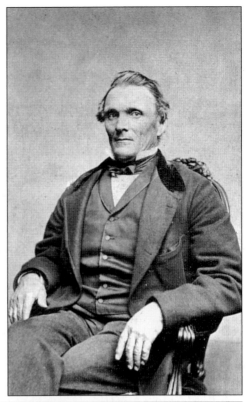

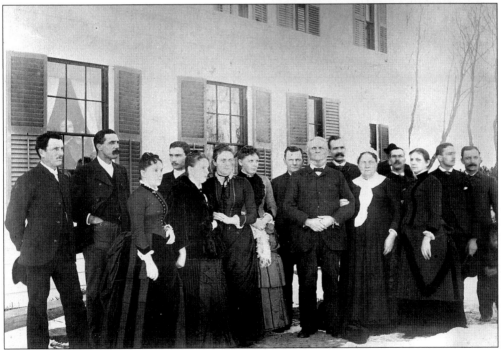

Here, the entire family is gathered on their parents' porch in celebration of their 50th wedding anniversary in 1889.

"Make a joyful noise." When Capt. Andrus Bearse, the brother of Nelson Bearse, was heard singing these lines from Psalm 100 as he walked to his house from Centerville Harbor, he was given the name "Old Hundred." Consequently, his house, which he built *c.* 1830, was called the Old Hundred House. Originally located at "four corners," the intersection of Main Street and Craigville Beach Road, the house was moved down Craigville Beach Road in 1930, when it was bought by John B. Cornish and used as a guesthouse for summer visitors. Bearse commanded two Centerville-built ships, the *Eliza Matilda* and the *Empress.* He was careful with his money and went so far as to build his own pine coffin. During the peak winter months, when Bearse was not commanding a ship, he was harvesting ice on Great Pond. In 1901, it was reported that he had filled his icehouses with 100 tons of ice that was six inches thick. He was also among the first to cultivate cranberries in Centerville.

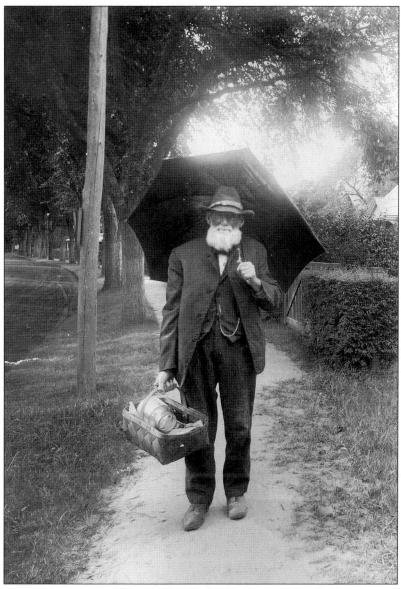

"If I told you you'd know, wouldn't you?" replied Capt. James Delap Kelley when asked where he was going. Born in 1840, Kelley had a long and varied seafaring career as a coastal and deepwater captain. An adept mariner, he commanded six vessels of varying rigs and tonnage without a single loss or accident. Eventually, he became a fishing captain, working the areas of Nantucket Sound and west to Block Island. Referred to as the "Mark Twain of Centerville," Kelley earned quite a reputation. He possessed a sharp wit and a droll sense of humor and was not without his eccentricities. He always walked with an open umbrella, claiming that it "keeps the sun from burning me and the rain from getting me wet." He was never without his woolen underwear either, believing that "in winter it keeps the heat in and in the summer it keeps the heat out." Although stories abound regarding this near-legendary figure, it is hard to separate truth from fiction. One tale in the village folklore is that he required his wife, Matilda, who was deaf, to sleep at the foot of his bed with a string attached to her toe in the event that he needed her to get something for him during the night.

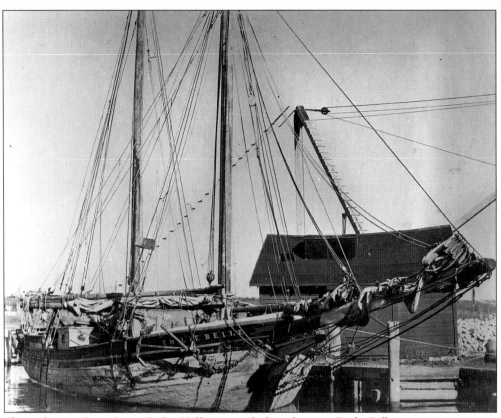

Shown here is Capt. James Delap Kelley's vessel, the schooner *Emilie Belle*.

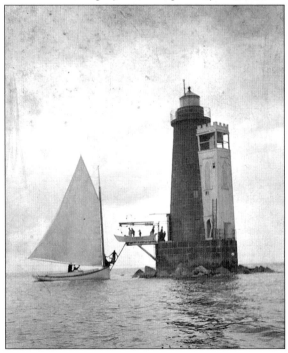

This early-1900s photograph shows Bishop and Clerk's Lighthouse, located three-quarters of a mile off Gammon Point in Centerville Harbor. It warned hundreds of captains of the shoal waters off the Cape and served as a marker for the channels into the harbors. It was demolished in 1951.

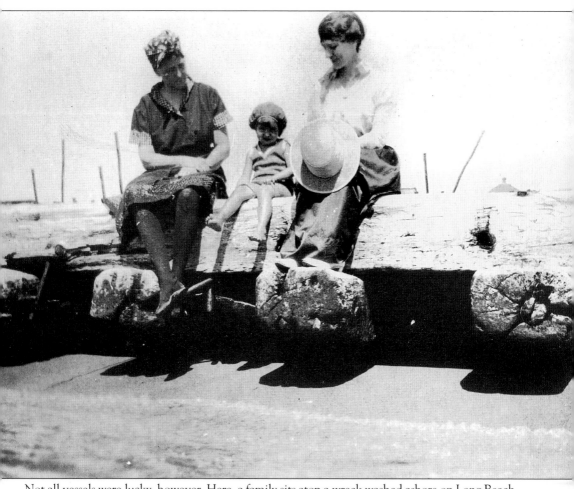

Not all vessels were lucky, however. Here, a family sits atop a wreck washed ashore on Long Beach.

Norfolk November 4"dy — 1827

Mr. William Phinney and Wife —
I deam it my dieuty to right you a
Line by male with a heavy hart to enfor
you did your famley the death of —
your Son Joseph by being nockd over
—boar with the halm, in scudding of the
Sch. under two Reefs in the folesail end
the same in the mainsail Runing —
dead a forest wind out, this sad misfortu
took place on the 31dy of October at 8 oclo
in the evening, at this time I was in
the Lattitude of 38 .° — Nd and Long ..
of 74.18 — Wd — near Chincoteague Sholes
in 15. fathoms of worter the wind now
blowing fresh from the N.E. we agreed
for Joseph to have the first watch and
stand till 10. oclock and then caull me
which he took the halm from me —
and steard on his Cours and in a bough
10. minuts as I see every thing was saft I
went below Henry standing with him
in his watch. I Jest gut my cloes off to ly
down when henry cryd out that the mate
was overboard which I was on deck and else
Mr. sandrows in two seckons to his assistance
I now found the Sch. Brochd tow with
every thing a back and henry enformd me
a mediately the Surcumstance as follaws

In 1827, William Phinney and his wife received this letter telling them of the death of their son Capt. Joseph Phinney, who was knocked overboard by the helm during a gale. "I deem it my dieuty to right [sic] again a line by male [sic] with a heavy heart to enform [sic] you that your son Joseph, by being nocked overboar [sic] with the helm . . . died. . . . This sad misfortune took place on the 31st of October at 8 oclock in the evening."

Three
ENTREPRENEURS AND BUSINESSMEN

While Jesse Crosby built the first gristmill in Centerville in the 18th century, "Uncle" Billy Fuller's Mill was one of two mills at work in the village in the early 19th century. The mill, located on the Bumps River, was the first to have a turning lathe. While Eli Phinney had built a gristmill for "grinding grain and carding wool" at the west end of the village, "Uncle" Billy's manufactured various kinds of wooden articles, including butter molds, chopping bowls, saltwork rollers, spoons, and clothespins.

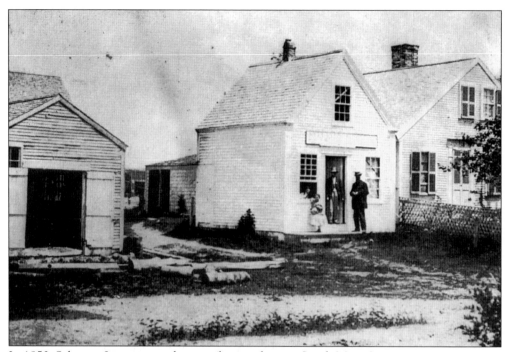

In 1850, Sylvanus Jagger opened an apothecary shop on South Main Street, near Bay Lane. He maintained a successful business until 1902. One resident recalled that "he concocted all sorts of remedies as well as parfumery. He said that the ladies of Hyannis could smell him as soon as he reached Dr. Fossett's corner. . . . That's about three miles, so his perfume must have been very potent!" Indeed it must have been as Jagger was "blessed with four wives in his lifetime."

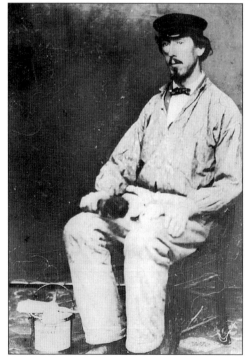

George Weaver sat for this curious portrait in 1862. As the paint can and paint-spattered clothing might suggest, he was a painter and opened a paint store in 1861, north of Clark Lincoln's tin shop. Perhaps this portrait was a form of advertising. Weaver was in business for 15 years.

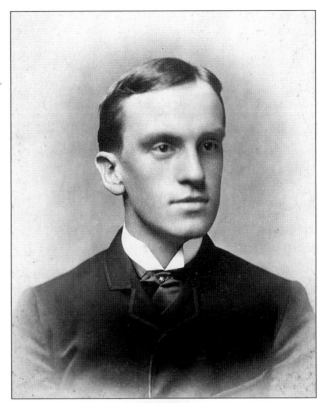

Andrew Gardner was one of 13 Centerville boys who went off to fight for the Union army during the Civil War. In 1866, after his return to the village, he opened up a leather and harness shop. Gardner's business, located in a little red cottage on the north end of Main Street, was profitable into the early 1900s. After his wife died at age 31, having lost their three-year-old daughter Olive, Gardner raised their two sons. He was respected as an intrepid businessman. In 1886, in a business deal that was the village buzz for weeks, he made a fancy leather harness for Frederick Coleman in exchange for his island on Great Pond, where he had a shooting blind for ducks. The spot is still known today as Gardner's Point. (Courtesy Sam Nickerson.)

Born in Brewster, Clark Lincoln settled in Centerville and opened up a blacksmith shop in 1842. In addition to contributing to village economics, Lincoln was also active in politics, serving in the state legislature as a Republican from 1880 to 1881. While his professional life flourished, his private life was not without its tragedies, as his first two wives died in their 30s. His last wife, Abigail Whelden, gave birth to two daughters. The first child, Mary Emiline, died when she was two, and, the second, Mary Edward, lived to be 87, living her entire life in the house her father built. (Courtesy Vivian Nault.)

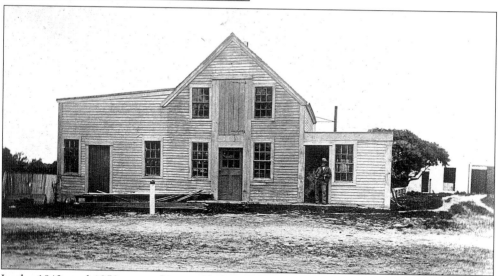

In the 1840s and 1850s, according to Clark Lincoln's daughter Mary, when the men returned from the sea they went to her father's shop at "the bend in the road" to "smoke, play checkers, and spin yarns." It was an interesting place that attracted many visitors. After her father passed away, "we were asked to preserve the store as a landmark to the people who knew its atmosphere where many happy hours were spent." In 1854, Lincoln built a home for his family adjacent to his shop. The blacksmith shop existed until 1860, when Lincoln switched over to the plumbing and stove business. Lincoln, seen here in the doorway of his shop, did all types of metalwork, specializing in the maintenance of stoves. With the exception of the central door on the second story, the "tin shop" looks today as it did in the 1860s. Today the two buildings comprise the Centerville Historical Museum.

In the late 19th century, Julia Crowell established an embroidery shop in Capt. Owen Crosby's 1830 house on Main Street. She sold embroidery, laces, stationery, and small wares. Her business reflects the increasing impact that women had in the village's economy and the changing status of women in American culture in the 19th century.

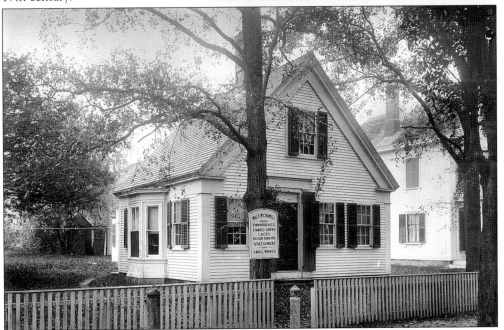

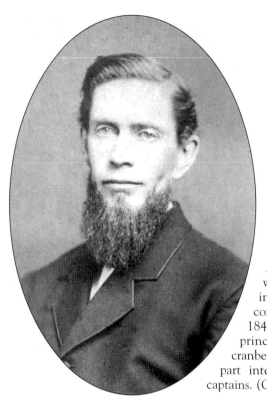

As early as 1837, Gorham Crosby and his wife, Annabelle, welcomed weary travelers into their home. Crosby, who began conducting the mail stage from his house in 1844, was a man of many enterprises. While his principal businesses were farming as well as cranberry farming and hotel keeping, he also owned part interest in ships commanded by Centerville captains. (Courtesy Vivian Nault.)

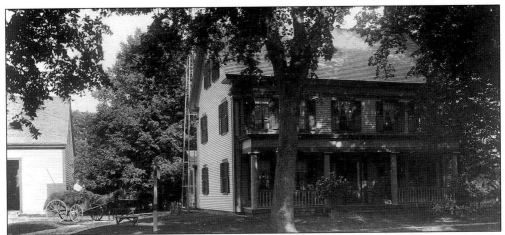

In 1859, when Gorham Crosby needed a larger house to accommodate his growing business needs, he moved his house next door and built a larger residence that was known by all as Crosby House. Nineteen rooms in all, there were 10 bedrooms to accommodate guests. Because of its central location in the town of Barnstable, Crosby's small hotel became a convenient meeting place for town and county officers to conduct business. The homestead also housed the village dentist two days a week. The inn was so popular, in fact, that when members of the Vanderbilt family passed through the village and asked to stay, they were turned away because there was not enough room to accommodate them. The house is one of the few homes in Centerville that is still in the possession of a direct descendant of the original owners. (Courtesy Melvina Crosby Herberger.)

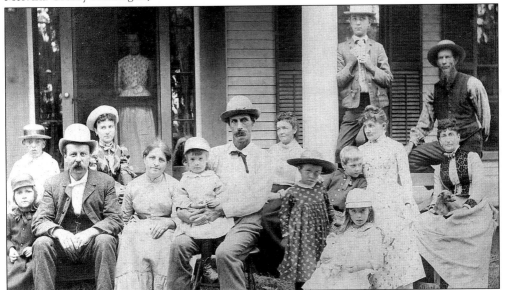

The Crosby House was always filled with family, friends, and visitors. This c. 1880 photograph shows a typical gathering on the front porch of Crosby House. As one visitor recalled: "Such a dinner as they always had on Sunday; such biscuits, everything cooked just as nice as Young's Hotel in Boston, and it seemed as if Mrs. Crosby could never do enough for you. Such a clean and wholesome place to sleep in, and then in the evening to sit down and have a game of checkers or dominoes, and to have some of the neighbors come in and sing, and eat apples. It was, indeed, solid rest after the long drive of the day. . . . I used to dread leaving such a place."

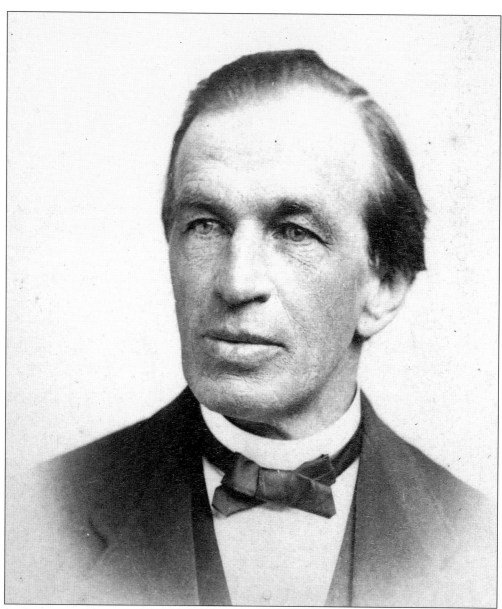

Ferdinand G. Kelley's name "remains a pleasant recollection of the community," remarked friend Howard Marston following Kelley's death. A shrewd businessman who possessed a dynamic energy, "F.G.," as he was known to all, made a lasting imprint on his fellow villagers and on the village itself. Born in Centerville in 1818, Kelley's reputation as a generous and fair-minded individual, with an undying sense of civic duty and a tremendous business acumen far exceeded the village's boundaries, gaining him great respect throughout Barnstable County. From 1841 to 1891, he owned the general store, which housed the post office, where he served as postmaster from 1839 to 1891. For 40 years, he served as clerk and treasurer of the town of Barnstable and, as justice of the peace, he married 140 happy couples. Intimately involved in the town's banking industry, Kelley was involved in nearly every major event of town business. His generosity prompted him to donate the land adjacent to his general store for the location of the Civil War monument for the town of Barnstable.

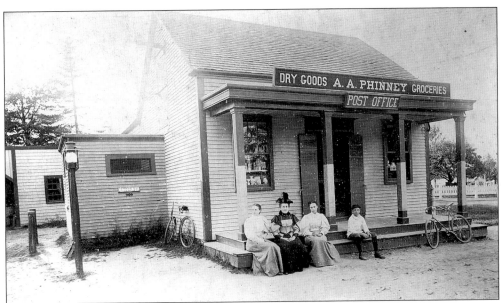

In 1837, the Centreville Trading Company, consisting of 37 men, took over the store that Freeman Marchant built in 1830, at the intersection of Old Stage Road and Main Street. The general store, which also housed the post office, was the nucleus of the town and remained in continuous operation for 154 years. In 1841, Jonathan Kelley and his son Ferdinand, who had been a store clerk, bought the shop. In 1854, F.G. bought out his father's share. F.G., who had served as postmaster since 1839, remained as owner and postmaster until 1891, when he sold the business to A. Alton Phinney. Phinney, who built an addition for the post office in 1901, sold the business to his brother Horace a year later. In 1984, the property was taken over by a real estate company.

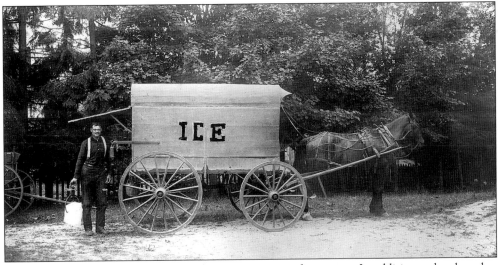

The ice truck was a common sight in the years prior to refrigeration. In addition to local market demand, the Northeast did a thriving business in cutting ice in winter and storing it in icehouses to be shipped to more southerly cities like Philadelphia. The Centerville Ice Company sometimes loaded Centerville vessels with ice to be carried to eastern seaboard ports and exemplifies the interconnectedness between Centerville's various industries.

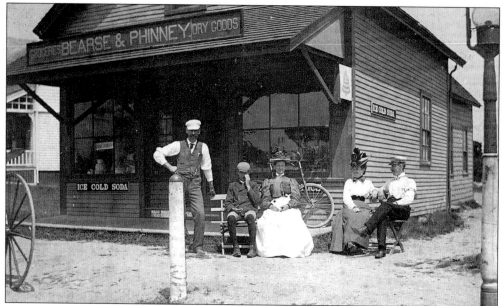

A second general goods store, located at what the villagers still call "four corners," or the intersection of Main Street and Craigville Beach Road, was started in 1847 by Ansel Lewis and Alvin Crosby. In 1886, they sold the property and business to Nathan Bearse and Harrison Phinney, a carpenter by trade, who continued the business into the early 1900s. Today a real estate office stands on the site.

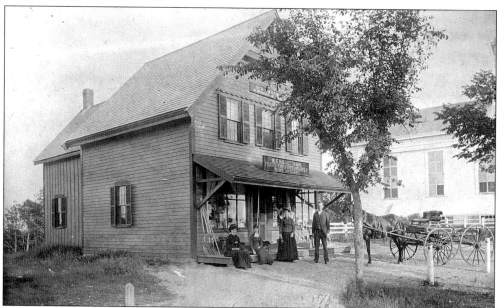

In 1856, a shoe store was opened up near the South Congregational Church on Main Street by John Case and Ambrose Lewis. In 1868, Moses Hallett purchased and enlarged it and, in 1874, his son Sam joined him in the business. They remained partners until 1892, when Sam became the sole owner. While the store offered general goods, its specialty was confections and ice cream. The store, a popular stop for families, exists today as the 1856 Country Store and boasts a variety of penny candies and gift items. (Courtesy Margaret Foster.)

One of several enterprising businessmen in the village, Moses Hallett established his success with his first store on Main Street. In the 1870s, he opened up another store in Craigville. He was a tall and skinny man whose stern features belied his kind and warm-hearted nature.

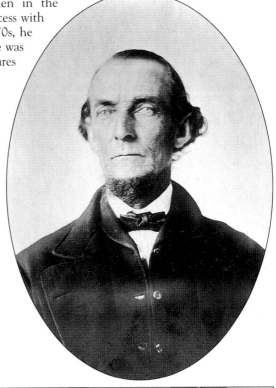

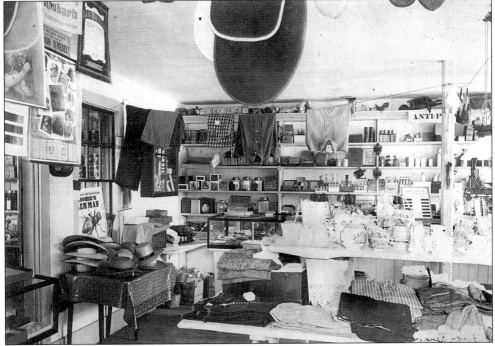

Shown here is the interior of Moses Hallett's store as it appeared in the 1880s. (Courtesy Margaret Foster.)

In 1902, the three principal store owners in town—Sam Hallett, Nathan Bearse, and Horace Phinney—posed for this memorable photograph.

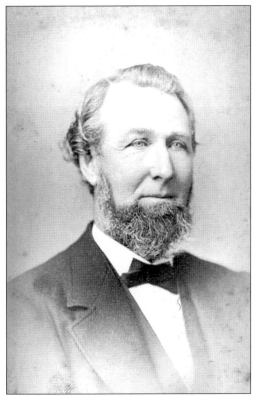

Russell Marston was born in 1816 and began his career when he went to sea as a cook and cabin boy at the age of nine, earning $3 a month. By the time he was 30, he had both command and ownership of the Centerville-built coaster *Outvie*. By mid-century, however, the heyday of the coastal trade was over and Marston saw the impending decline. In 1847, he sailed his ship to Boston and tied a broom to the masthead, which meant the vessel was for sale. With the proceeds, he bought a half interest in a small food shack with 10 stools on Commercial Wharf in Boston. Marston remained a Centerville resident and took an active role in village concerns. He was a true gentleman, and his good looks, combined with his humorous nature, made him popular with the ladies.

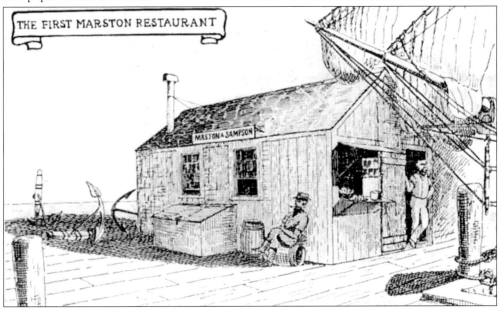

THE FIRST MARSTON RESTAURANT

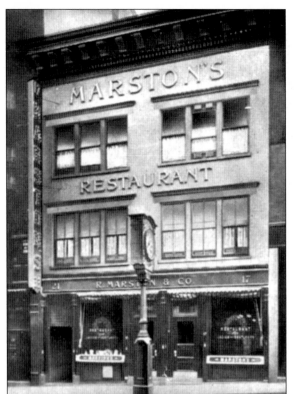

In 1853, responding to the success of his modest food shack on Commercial Wharf, Russell Marston opened up a restaurant at 13 Brattle Street in Boston. Less than a year later, due to its unprecedented success, Marston moved to larger quarters. Marston's business continued to grow, his son Howard joined him and, by 1908, R. Marston & Company had become a Boston institution, with three locations at Brattle Street, Hanover Street, and Commercial Street. In addition to basic fare, delicacies on the menu included fish chowder, cod tongues, mutton chops, oyster pie, bird's nest pudding, and boiled tripe. An advertisement of 1908 stated that combined, Marston's restaurants occupied 60,000 square feet of space, employed 600 individuals, and served more than 10,000 people daily.

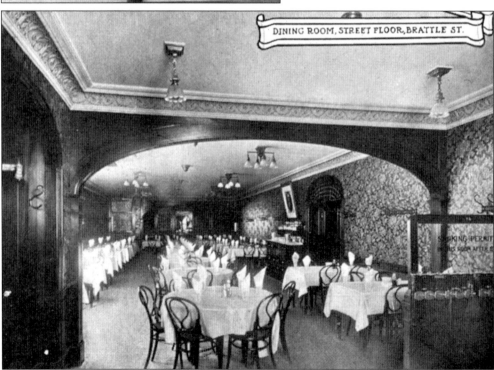

This view shows the dining room of the Brattle Street restaurant.

At Marston's Saloon.

When morning light your eyelids greet
Haste with the throng to Brattle street;
And when the sun stands high at noon
Go then, to Marston's neat saloon.

At evening hour with heart elate,
Seek those who for your coming wait;
Those Cape Cod girls with airy tread
See that the customers are fed.

How glad they move—their winsome smile
Lights up each countenance the while.
Here Abbie trips it round the room,
Louisa comes in rosy bloom.

With tranquil smile our Sarah looks
While Belle stands figuring at the books;
Addie anon joins in the train
And Betsy works with might and main.

When supper's done, how sad am I,
For I must bid these girls good-bye,
I'll breakfast quick, and oh, the pity
I then shall leave dear Boston city.
Yet often in my thoughts I'll be
At Russell Marston's drinking tea.

—Eugene Tappan.

This poem about Marston's restaurant on Brattle Street was written by Centerville
schoolteacher Eugene Tappan.

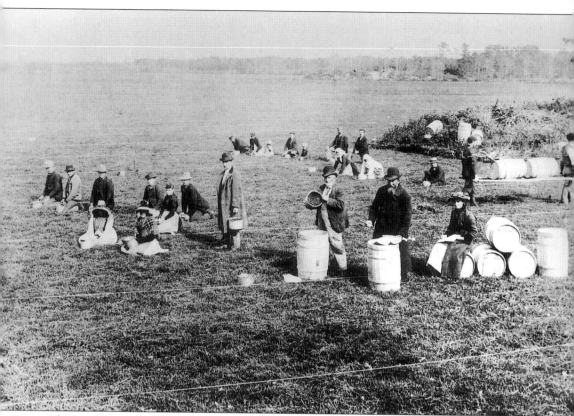

The harvesting of cranberries has long been an economic staple of Centerville as well as Cape Cod. In fact, it was a Centerville man by the name of Daniel Lumbert who invented the first cranberry scoop. Called a snap scoop, this device opened and shut by the pressure of one's thumb. Lumbert was bought out, however, and thereafter his device was called a makepeace scoop. In the 1850s, the cranberry started to assume increasing economic importance in the village's economy, supplanting the waning maritime business. In fact, a number of Centerville sea captains, such as Hiram Kelley and Eli Phinney, turned to cranberry farming in their retirement. Others, such as Gorham and Aaron Crosby, John Scudder, Andrus Bearse, and Howard Marston, converted almost all of the lowland areas into cranberry bogs. Here, Clara Jane Hallett sits on a barrel and records the harvest.

Four

SCHOOL DAYS

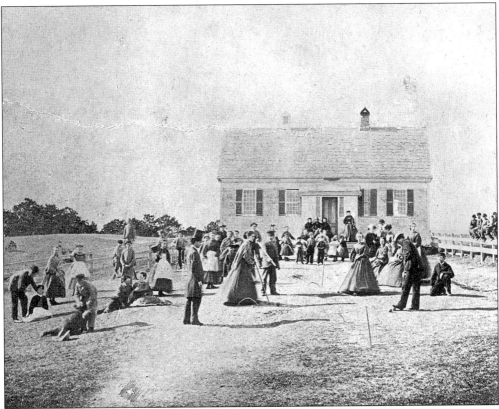

In 1798, the first school building was constructed on Phinney's Lane, next to the old burying ground and served as a schoolhouse until 1880, when a new building was constructed on Main Street. Because of its location, it was intended for children living in the north end of town. It was a one-room schoolhouse with a large open fireplace. The teacher's desk was located on a raised platform, with an aisle in the center leading up to it and with the students desks and benches arranged in orderly rows on either side of the aisle. Harvard-educated John Richardson was Centerville's first schoolteacher. Reading, writing, and arithmetic were the primary subjects taught in a school day that ran from 9 a.m. to 4 p.m. Here, Centerville children are enjoying a game of croquet in the schoolyard.

"A church on every hilltop and a school in every valley." These were the words of Centerville schoolteacher John Pratt, thus expressing the understanding of early residents that education was essential to the well-being of society. Documents from the period show that there was an early and ardent interest in education. Residents built schools as the need arose, and they were prompt in appropriating the annual requisite funds for sustaining their schools. In 1840, Centerville had two of the 24 schoolhouses in the town of Barnstable. (Courtesy Vivian Nault.)

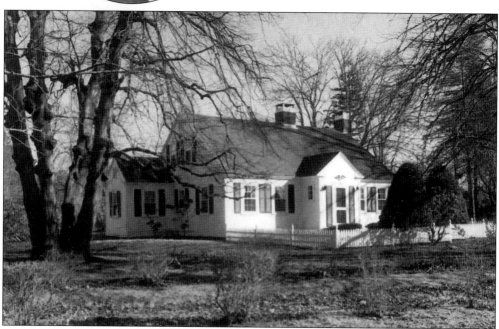

In 1887, the Phinney's Lane schoolhouse was sold for $302.60 to Russell Marston, who moved it to the corner of his property on Linden Avenue, where it was used as living quarters for hired help. The cupola was removed and used by the neighborhood kids as a playhouse. The original schoolhouse is now a private residence. (Courtesy Vivian Nault.)

Eugene Tappan was one of Centerville's first teachers and was responsible for organizing the village's first library. (Courtesy Vivian Nault.)

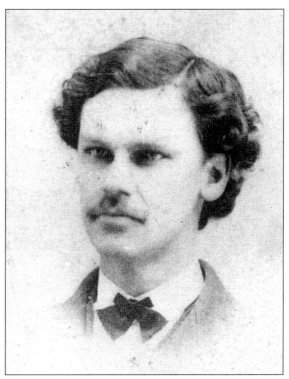

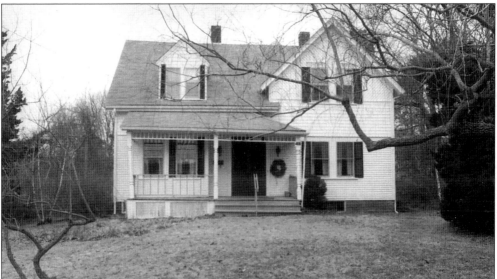

A second school was constructed in 1826 on South Main Street for children living in the south end of the village. The school housed both a primary and grammar school, and its outstanding physical characteristic was a pair of stained-glass front doors. It was also a one-room schoolhouse with an entry for storing clothing and firewood. Children began attending at age four, and the school year encompassed a three-month term in summer and a three-month term in winter. When it was consolidated with the Phinney's Lane school in the new building on Main Street in 1880, Capt. Horace Bearse bought the building and moved it to his property, where it stands today.

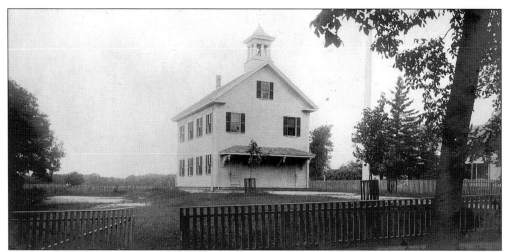

The new schoolhouse was built on Main Street in 1880 for $1,700 and served in this capacity until 1957, when the present Centerville Elementary School was built on Bay Lane. On Columbus Day 1892, the school's first flagpole and flag were raised, symbolizing the discovery and promise that comes with an education. To ensure attendance, Capt. Eli Phinney served as the truant officer. According to reports, he was so stern and strict-looking, kids did not dare skip school for fear that he would show up on their doorstep. When the elementary school was moved from here into a modern building in 1957, the post office, located in Phinney's General Store at the time, was moved into the recently vacated school building. It remained there until 1976, when the volume of mail had increased so tremendously that it necessitated the construction of a modern facility. Today, the Main Street school's original bell rests on the lawn of the Centerville Historical Museum. It was restored and dedicated in 1997 through a collaboration between the Centerville Historical Museum and the Centerville Elementary School fourth grades.

A unique aspect of the 1880 Main Street school building is the mural on the second floor that was commissioned by the Federal Arts Project as part of the Works Progress Administration in the 1930s. The mural, painted by Vernon Coleman in 1935, depicts James Delap Kelley, a Centerville sea captain whose reputation was legendary in his dory fishing. Today, the building is owned by the Centerville Parks and Recreation Department and is used as an activity center for seniors, a day care, and a classroom for students with special needs.

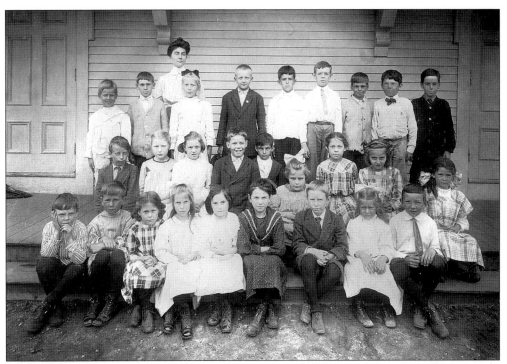

Shown here is the Centerville Grammar School Class of 1913.

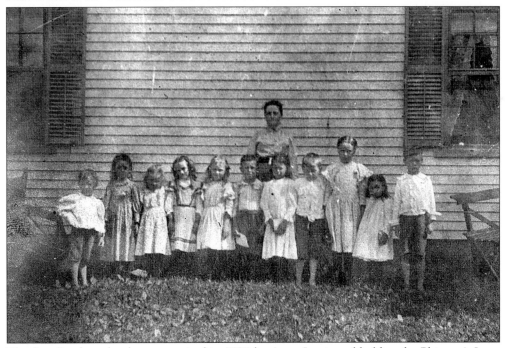

The first Sunday school was organized in 1822 by Anna Lewis and held at the Phinney's Lane school, where she was a teacher. "Aunt" Anna died in 1880 after "a long life of usefulness." This photograph shows a group of Sunday school students from *c.* 1890 with Anna's successor, Mrs. Aaron Crosby.

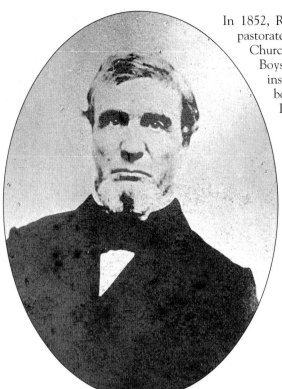

In 1852, Rev. Elisha Bacon, after concluding his pastorate at Centerville's South Congregational Church, opened the Bacon Home School for Boys. Not only did he provide private instruction to these young boys, but he boarded the students in his home as well. It was said that Bacon knew and called every person in the village by their first name. After his death, a local businessman commented, "Mr. Bacon could ask one to do some needed act for the church, yet so kindly and naturally make the request, one almost felt it a favor to one's self to comply."

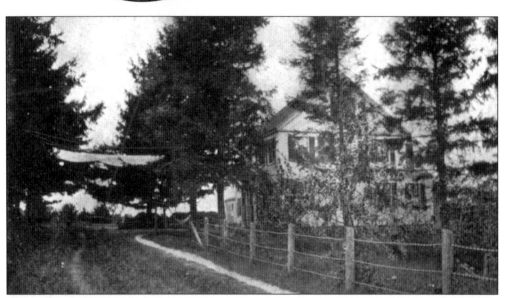

The Bacon Home School for Boys was located on what is now called Bacon Lane. Pupils came from towns on Cape Cod initially, but the school's reputation grew quickly. As it became increasingly popular, with students arriving from all over Massachusetts and other parts of the United States, Rev. Elisha Bacon was obliged to hold classes in Liberty Hall, the public gathering place from 1846 to 1876 and located on the property adjacent to Bacon's school. It was not unusual for Bacon to have 25 or more students to teach and care for at one time.

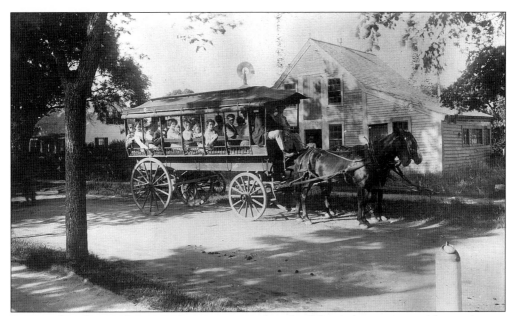

Prior to the advent of motorized conveyances, the school barge (a cart covered by an awning and pulled by two horses) transported students from Osterville and Centerville to the high school in Hyannis, established in 1872. The pick-up point in Centerville was in front of Clark Lincoln's tin shop, known as "the bend in the road." This photograph was taken in 1908 and shows that there was standing room only for the trip to the high school.

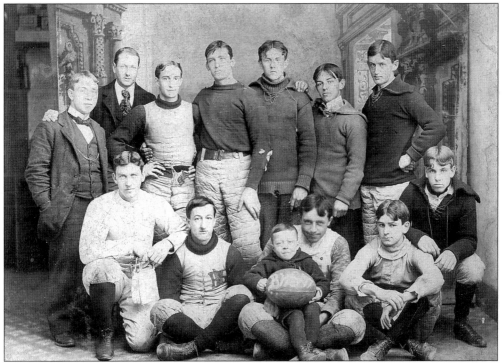

Shown here is the Barnstable High School Class of 1898 with students from Centerville, Osterville, and Hyannis.

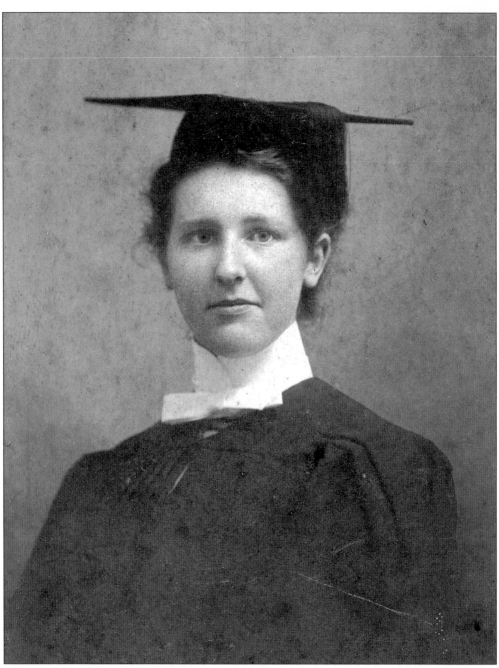

Augusta Kelley Meigs, the daughter of sea captain Hiram Kelley, was one of the first Centerville women to earn a college degree and represents the new generation of women that was coming of age in Centerville. Although this reflected the times in regards to the changing status of women, it was as much a reflection of Meigs's parents' support of her endeavors. Meigs attended Middlebury College in the late 1890s in pursuit of a teaching degree, which she easily accomplished. Her career as a teacher was short-lived, however, as she lost her hearing at a young age and was forced to retire from the profession. Years later, she served for 14 years as Centerville's postmistress in Phinney's store on Main Street.

Five
SACRED PLACES AND PUBLIC SPACES

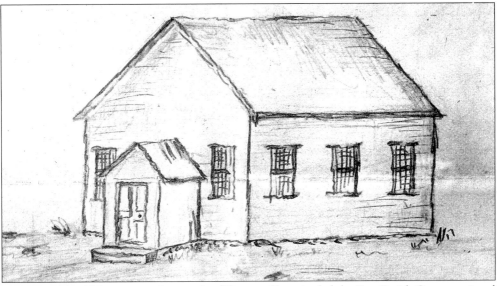

For most of the 18th century, the people of Centerville attended the East Parish Congregational Church on Cobbs Hill in the village of Barnstable, built in 1717. Women would walk the entire distance carrying their best shoes and stockings in their hands until they arrived at a large rock at the roadside located about a mile from the church. There they would change, leave their walking shoes behind the rock, and change back following services. The church was not heated, so villagers brought foot warmers filled with coals. Services lasted all day with a break at noon, allowing parishioners to go to nearby houses and replenish their coal supplies. Centerville's first church, depicted here in an early drawing, was the fourth church in Barnstable and was built in 1796 on Phinney's Lane at the southern end of Great Pond. It doubled as a meetinghouse, following the Puritan tradition of using the church for secular as well as spiritual purposes. As a house of worship, villagers enjoyed services every fourth Sunday when the minister from the East Parish Congregational Church would visit and deliver a sermon. On remaining Sundays, villagers would once again make the long walk back to the East Parish, carrying their shoes with them.

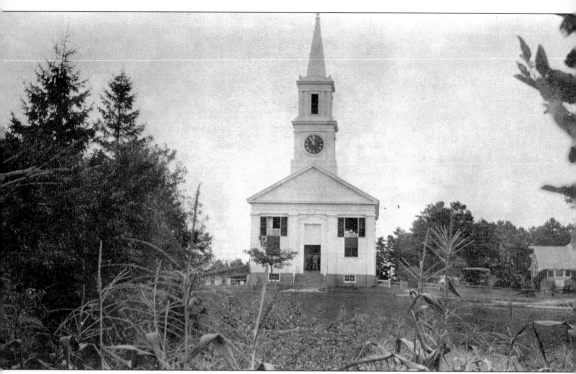

In 1816, the South Congregational Society was organized with 11 members. Rev. Josiah Sturtevant was ordained as the first minister in 1819 with an annual salary of $300. When the nucleus of Centerville's population moved from Phinney's Lane south to Main Street, it was decided to move the 1796 church, which was the center of both its moral and intellectual life. In 1826, the Colonial building was dismantled and carried by oxcart to its current location on Main Street and, in 1848, the steeple and bell were added. Before the neighboring village of Osterville organized a church of their own, they attended the newly established South Congregational Church.

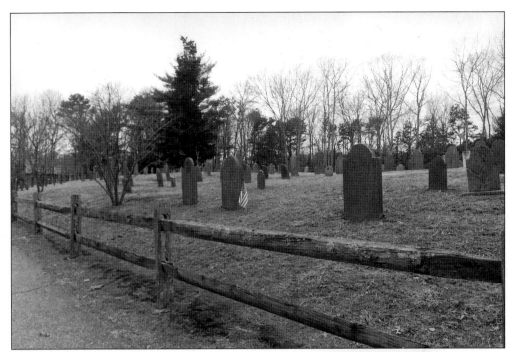

When Reverend Sturtevant died in 1825, he was buried in the Ancient Cemetery. The first of four cemeteries to be laid out in Centerville, it was alternately called Schoolhouse Burying Ground because of its proximity to the Phinney's Lane school. The final resting place for some of Centerville's earliest inhabitants, it is the location of the oldest gravestone in the village, that of Jonathan Hamblen, who died in 1743 at the age of 74.

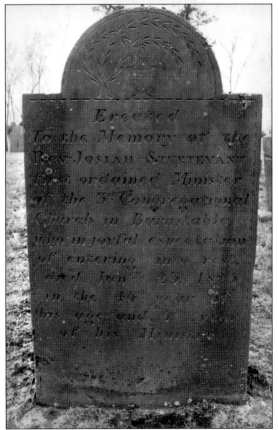

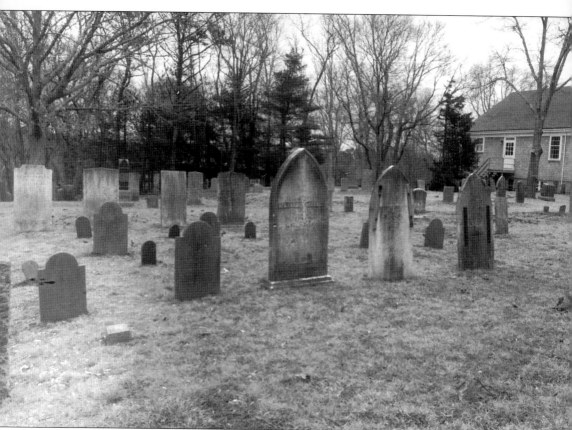

The cemetery located behind the South Congregational Church on Main Street was needed to supplement the Ancient Cemetery. Grave markers tell the stories of village life in the 18th and 19th centuries. The names of Hallett, Bearse, Kelley, Lewis, and Crosby reveal a tale of lives well lived, but also of lives lost at sea, of mothers dying in childbirth, and of children dying before they could experience life.

The location of 35 shipmasters' graves and the Crosby, Marston, and Kelley family plots, the grassy paths of Beechwood Cemetery travel a nostalgic course through Centerville's formative years. In November 1855, a meeting was held by a group of Centerville residents—including Clark Lincoln, Gorham Crosby, Sylvanus Jagger, John B. Cornish, and Eli Phinney—and the Centreville Cemetery Association was formed. Five acres of suitable land was purchased on Old Stage Road, just above the main section of the village, and Ferdinand G. Kelley hired a landscape gardener from Boston to lay out the future cemetery. Plots were sold for $200. In 1873, the name was changed to Oak Grove and again, in 1901, when it was changed to Beechwood Cemetery. Each Memorial Day, the cemetery is used as part of the celebration and remembrance.

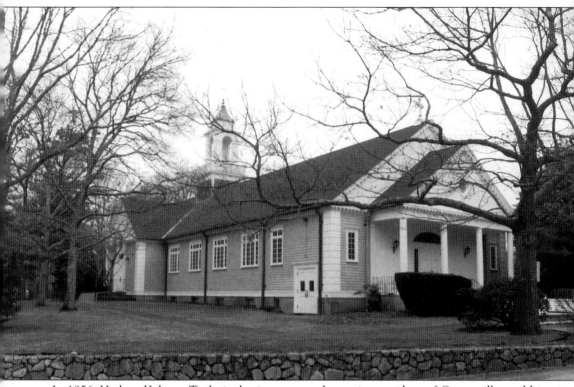

In 1956, Herbert Kalmus, Technicolor inventor and one-time resident of Centerville, and his second wife gave seven acres of land in Centerville to the Catholic diocese. In 1957, Our Lady of Victory Church, modeled after St. Joseph's Church in Dighton, Massachusetts, was built on a hilltop overlooking South Main Street. Surrounded by evergreens, the church is very secluded. It is here that Caroline Kennedy married Edwin Schlossberg in 1986.

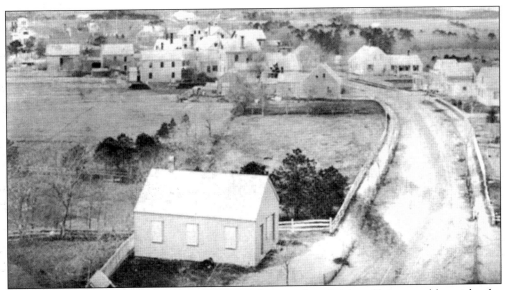

In 1846, the village apothecary, Sylvanus Jagger, found himself in trouble with the Congregational church after he made "controversial comments" inside the church building at secular meetings. Immediately, a group of the village's most liberal thinkers organized and formed a committee to find land in the village where a hall could be built so "every man would have the privilege of giving expression to his thoughts on any subject." The committee—which consisted of Jagger, Andrus and Nelson Bearse, and Ferdinand Kelley—secured a plot of land on Main Street near Elisha Bacon's private school and boardinghouse. Aptly named Liberty Hall, the structure served as a meeting place for "come-outers," those who left the church due to doctrinal reasons. In 1877, a larger hall was constructed and Gorham Crosby purchased the Liberty Hall building and moved it to his property, where it served as a cranberry storage house. (Courtesy Vivian Nault.)

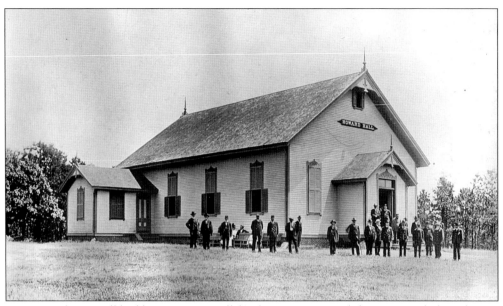

By 1876, Liberty Hall had become too small for the growing crowd that was regularly gathering there, so Ferdinand G. Kelley, in characteristic fashion, devised a plan to finance the building of a new hall. Shares were sold for $5 to finance the building. Named after Kelley's son-in-law Howard Marston, Howard Hall was dedicated on December 24, 1877. Built on the land where the present library now stands, it became the location of a variety of cultural and social events as well as public gatherings. Augusta Kelley Meigs, daughter of Centerville sea captain Hiram Kelley, reminisced: "Papa loved to dance but mother didn't. . . . I wasn't allowed to learn such a wicked pastime although myself and the other children must have made nuisances of ourselves as we slid across the hardwood floors of Howard Hall." Howard Hall remained the center of the village's social and cultural life until 1944, when the building was so badly damaged by a hurricane that it had to be torn down.

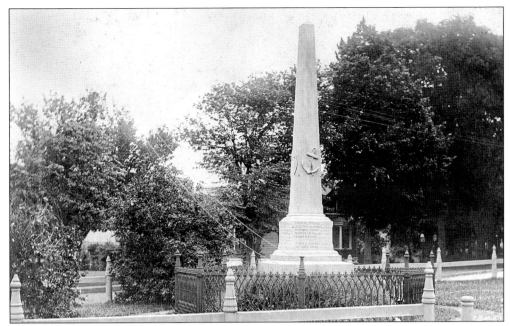

When the town of Barnstable decided to erect a monument in remembrance of their heroes who had served during the Civil War, they chose Centerville because of its central location in the town. Ferdinand Kelley donated the land, which was next to his general store. On July 4, 1866, the monument, inscribed with the names of the 32 Barnstable men who risked their lives to preserve the Union, was erected in Monument Square at the intersection of Main Street and Old Stage Road. It was the second monument in Massachusetts to honor the soldiers of the Civil War and included the names of six Centerville men who died out of the 19 who served.

"Greater love hath no man than this, that a man lay down his life for a friend." In the early 1920s, a boulder remembering the 24 individuals who left Centerville to respond to their country's call in World War I was placed and dedicated in front of Howard Hall. In 1930, it was moved to Monument Square, where it was placed beside the Civil War monument. Today, another group of dedicated villagers has organized to design and raise the funds for a monument that will commemorate the men and women from Centerville who served in World War II, the Korean War, and the Vietnam War.

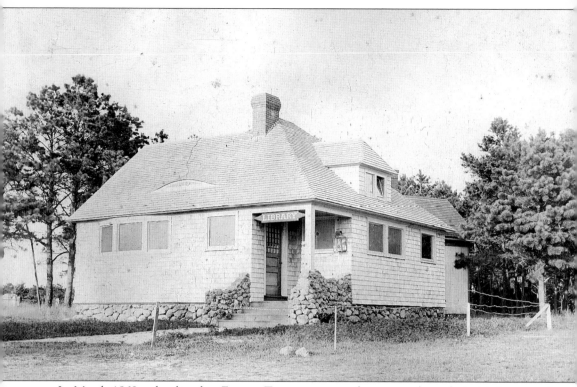

In March 1869, schoolteacher Eugene Tappan convened a group of people in his home and organized the Centreville Library Association with the purpose of establishing a public library for the village. The group started a small library of 308 books in Moses Hallett's store, where they remained for seven years. For two years, the books were moved to Nelson Phinney's carriage shop on Main Street. In 1878, the books were temporarily moved to the anteroom of Howard Hall and, in 1881, a small building was erected that served as the library until 1897. At that time, it was agreed that the library had outgrown the space, and this square-shingled bungalow was built beside the church and remained the village's repository until 1957, when Charles Lincoln Ayling and the people of Centerville provided the funds for the construction of the present one-story brick building.

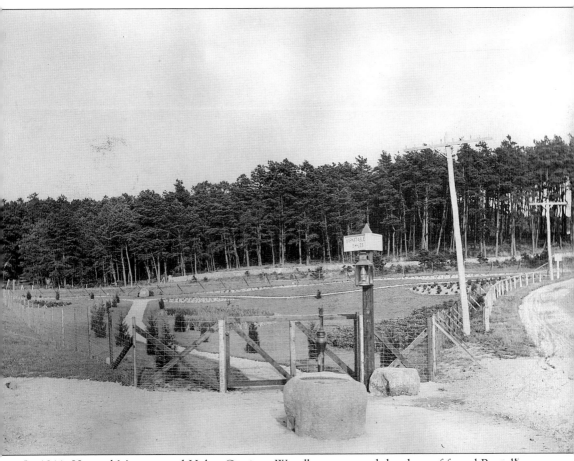

In 1911, Howard Marston and Helen Garrison Woodbury, son and daughter of famed Russell Marston, purchased a triangular piece of land between Phinney's Lane and Main Street from Simeon Childs for $1. Lit by a gaslight street lamp, the grassy meadow was bound by two dirt roads and a stone wall. It was here that they created Mother's Park, a beautiful parklike space in memory of their mother, Sarah Crosby Marston, that was elegantly planted with a variety of trees and shrubs. The park was designed after the gardens at Howard Marston's estate Fernbrook, which had been laid out by Frederick Law Olmstead. The road behind the park, originally a small footpath created by pedestrians taking a shortcut, was later used by horses and cyclists and was eventually paved for automobiles.

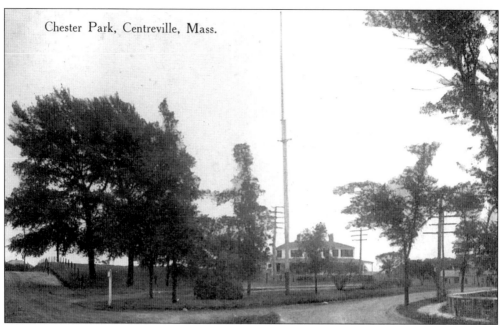

Chester Park, Centreville, Mass.

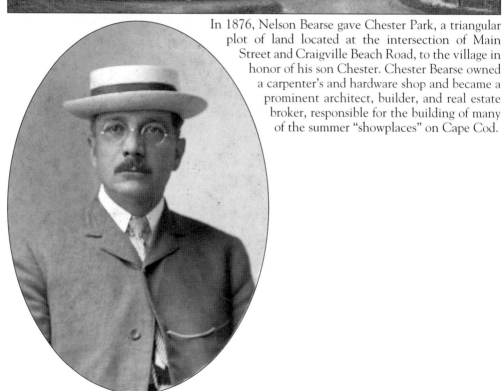

In 1876, Nelson Bearse gave Chester Park, a triangular plot of land located at the intersection of Main Street and Craigville Beach Road, to the village in honor of his son Chester. Chester Bearse owned a carpenter's and hardware shop and became a prominent architect, builder, and real estate broker, responsible for the building of many of the summer "showplaces" on Cape Cod.

Aaron Spooner Crosby Park—located at the intersection of north Main Street and Pine Street, across from Long Pond—is named after Gorham Crosby's son Aaron. It was given by his children Evelyn and Sumner in 1952. One of Elisha Bacon's stellar students, Crosby went on to become justice of the peace, notary public, fire warden, auctioneer, surveyor, appraiser, farmer, and state legislator. Known by Centerville residents as the "village squire," Crosby possessed an encyclopedic knowledge of the village.

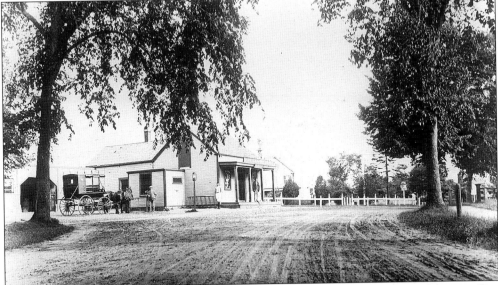

In the 19th century, there was no mail delivery to people's houses, so when the post office opened up in 1834, it became the daily gathering place for the village. When the post office was established on Main Street, the name of the village was changed from the Native American Chequaquet, which means "pleasant harbor," to Centreville. The first mail was delivered by Richard Phinney and carried in saddlebags on horseback. Until 1844, when Gorham Crosby took the stage route over, Deacon James Marchant ran three trips per week from Hyannis, Centerville, and other shore villages to Sandwich. The Centerville Post Office remained in this spot until 1957, when it was moved into the former school building on Main Street.

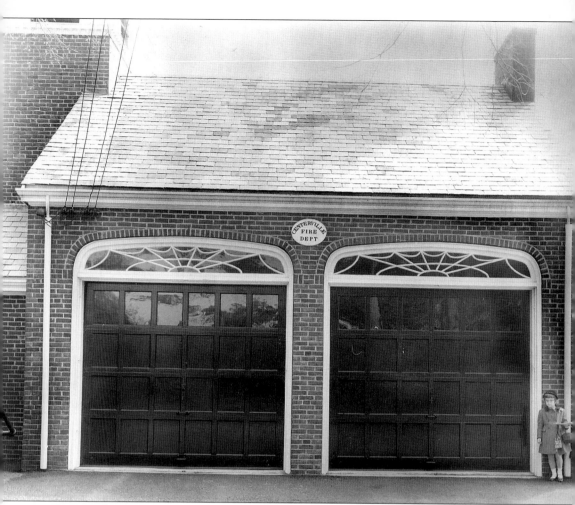

In 1925, local residents, including Charles Doubtfire and Charles Lincoln Ayling, spearheaded a grassroots money-raising campaign to establish a fire department in the village. On January 29, 1926, inhabitants of the fire district voted to establish the Centerville-Osterville Fire Department. The meeting, which was held at Union Hall in Osterville, allotted $20,000 for the purchase of two parcels of land for the construction of two firehouses and $25,000 for the purchase of two pumping engines and other firefighting equipment. The Centerville fire station was built in 1926 on Main Street, next to Howard Hall, on a lot that was purchased from the Howard Hall Association for a mere $200. As this photograph from 1940 shows, the building was constructed to "harmonize with the typical colonial architecture of the Cape" and not to "detract in any way from the picturesqueness of the villages." The station stayed in use until 1990, when the fire districts were reconfigured. (Courtesy Lt. Britt Crosby, Centerville-Osterville Fire Department.)

In the early 1950s, a group of Centerville residents was encouraged and organized by Dorothy Waterhouse, a collector of historic wallpapers, to collect clothing, linen, tools, quilts, and other objects relating to Centerville's past. Waterhouse, who lived in the parsonage built in 1837, had amassed quite a collection of her own. In the upstairs bedroom she kept her collection of historic gowns. In the rear of the house she built a studio that she used for her business in antique wallpapers. In 1952, Waterhouse and her fellow historically minded friends formally organized the Centerville Historical Society. Since they did not have a building, they hosted events and put their collections on exhibit on the front lawn of their homes.

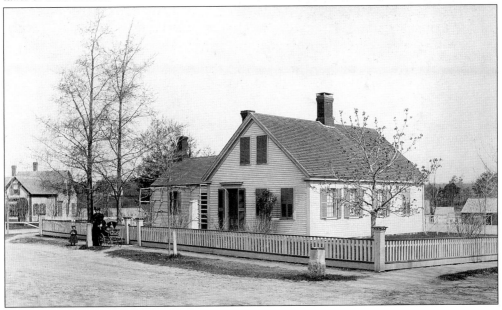

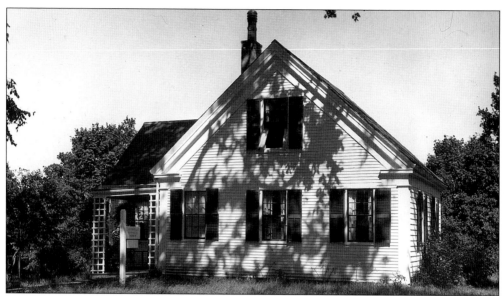

When Mary Lincoln died in 1955, her house, the residence built by Clark Lincoln in 1854 on Main Street, was given over to the Centerville Historical Society, who then transformed it into a museum. Less than 10 years later, the collection had grown to the point that an addition was needed. In 1962, Mabel Phinney gave the home of her grandmother Harriet Crosby Phinney to the Centerville Historical Museum. As the house was a distance from the Mary Lincoln house, it was decided to sell the house and use the proceeds to build an addition, which they did and named it the Dorothy Waterhouse Room to honor the founder and first president. In 1972, when resident Charles Lincoln Ayling died, the trustees of his estate, which included Waterhouse, unanimously decided to donate the majority of his private collection to the Centerville Historical Museum. Substantial funds to build an addition to house them accompanied this gift. Through the bequest of Augusta Kelley Meigs, the daughter of a Centerville sea captain, a gallery was added to exhibit the museum's maritime collection.

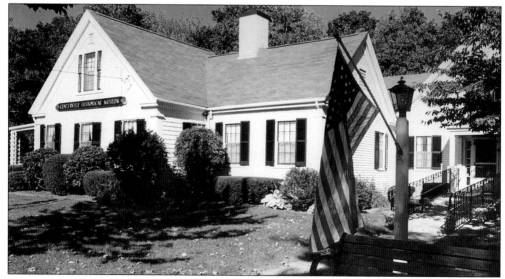

The 14-room Centerville Historical Museum is shown as it appears today. In 2000, a handicap access ramp was added and the maritime gallery was totally renovated.

Six

COMMON FOLK,
UNCOMMON LIVES

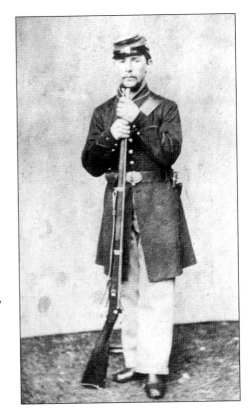

In 1904, Edward Childs stated during an Old
Home Week toast, "The boys of Centerville . . .
donned the Blue and went to the front that the
Union might be preserved." Seen here at the
time of his enlistment, Childs was one of 19
Centerville men to answer the call to arms
during the Civil War and carry on a tradition of
patriotism in the village. During the Revolution,
even before it had established itself as a village,
the area that was then known as Chequaquet,
sent more than eight men into action. The War
of 1812 and the Civil War fully involved its
residents, not only on the battlefronts but also
along the coastline, where blockade running
became commonplace.

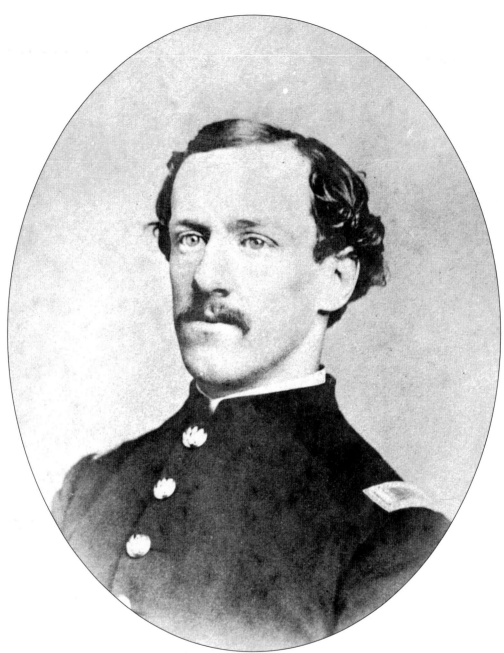

Augustus D. Ayling, who served in the Union army from 1861 to 1866, began his distinguished military career as an enlisted man, ultimately rising to the rank of first lieutenant. During this war, he kept extensive diaries of his varied experiences, and it is through his writings that one can come to understand the experience of the common soldier. Highly literate, perceptive, and a detailed observer of the events he recorded, Ayling witnessed firsthand the battle of the *Merrimack* and the *Monitor,* the peninsular campaign of McClellan, the Battle of Fredericksburg, and the fall of Vicksburg. After the fall of the Confederacy, Ayling served in a regiment occupying the capital, Richmond, Virginia. At this time he was appointed judge advocate and tried court martial cases.

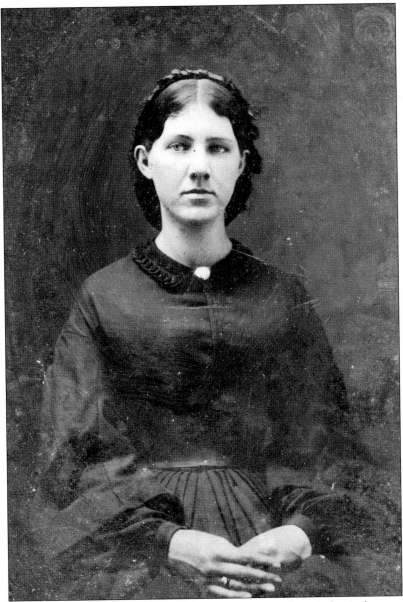

Some of the more lighthearted and touching entries in Augustus D. Ayling's diary involve his musings about Cordelia Kelley, with whom he fell in love when his regiment was sent to Paris, Kentucky. Ayling and Cordie, as she was called, were parted when his unit was transferred to Mississippi in support of Grant's Vicksburg campaign. In 1863 or 1864, Kelley gave this picture to Ayling. In his diary entry of August 30, 1863, he writes, "Lt. Pizer . . . brought me a note from Cordie asking that she be released from her engagement to me." Ayling was completely taken by surprise and quite dumbfounded by her request. On September 14, 1863, he again met her in Paris, Kentucky, where she explained that she was in love with a "young Ohio officer." The inside of the envelope, which contains this picture, includes her handwritten note: "Please never take it any farther out of the case than it is now—I will tell you why when I see you." When the tintype was pulled from its case, it revealed what must have been a painful truth for Ayling, as upon her finger was now a wedding band.

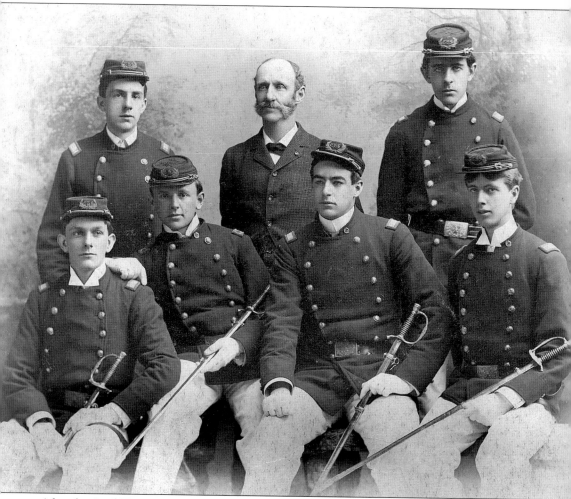

After the Civil War, Augustus D. Ayling returned to his job as a traveling wholesale distributor for J.C. Ayer of Lowell, selling sarsaparilla and hair restorer. While stopping at Crosby House, Ayling met Elizabeth Cornish, the daughter of coastal captain John Cornish. According to Ayling's good friend Aaron Crosby, he was smitten and they married in December 1869 at the South Congregational Church. It was not long, however, before his longing for the military life called him back into service. While living in Nashua, he joined the New Hampshire National Guard, for which he served for 30 years. After three years, he was appointed by the governor of New Hampshire to the office of adjutant general in command of the entire state guard. When Ayling retired in 1907, he was the senior-ranking adjutant general of the United States. He is seen here in 1895 with a class of Concord, New Hampshire High School cadets.

The daughter of Centerville sea captain John Cornish, Lizzie Cornish married Ayling in 1869 and was a devoted wife and mother. It was undoubtedly Lizzie to whom Augustus D. Ayling was referring when he gave a light-hearted toast at the 1904 Old Home Week celebration entitled "Woman, Queen of the Home." He began his toast with "I wish that one with a better knowledge of the subject had been selected for this duty, for to me, woman in all circumstances and under all conditions is a sealed book, an unsolved problem, an unknown quantity. . . . I have been diligently studying women for many years and am still in the kindergarten."

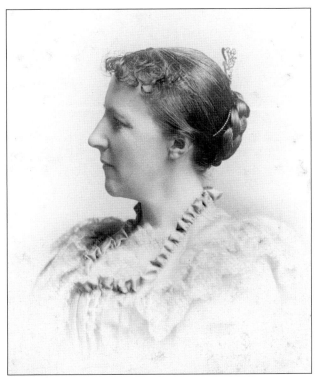

After Augustus D. Ayling married Lizzie Cornish, they built a house on the Centerville River, which he called "the Barracks," reflecting his lifelong dedication to the military. Because of his position with the New Hampshire National Guard, it was a secondary residence and summer vacation home. In the early years, Ayling and his family spent their summers in a tent.

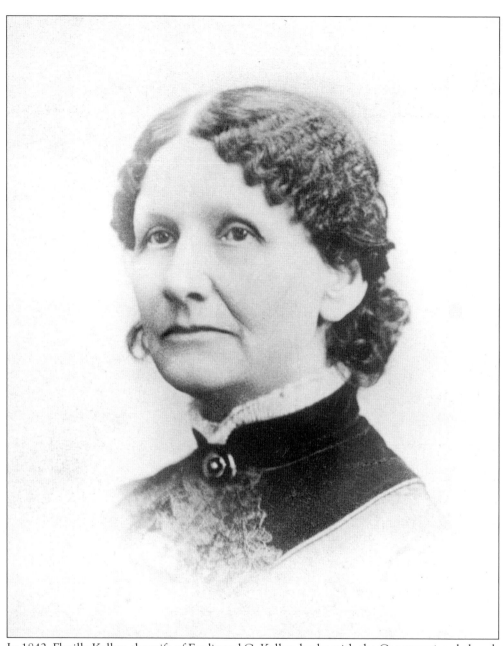

In 1842, Florilla Kelley, the wife of Ferdinand G. Kelley, broke with the Congregational church over doctrinal differences. A "come-outer" like her husband, she also shared strong sentiments over the issue of slavery. The Kelleys' strong abolitionist sentiment was shared by many in the village, and several of its residents were actively involved in antislavery activities. In 1850, a committee of three was appointed by the South Congregational Church to draw up resolutions on slavery. These resolutions emphasized that slavery was a great and unparalleled wrong, a "violation of God's immutable law," and that the church should be impelled to "exclude from the communion table and the pulpit, all men who are thus criminally guilty." As the minutes of the 1850 meeting read, "we cannot fellowship as Christians those who voluntarily hold in bondage their fellowmen."

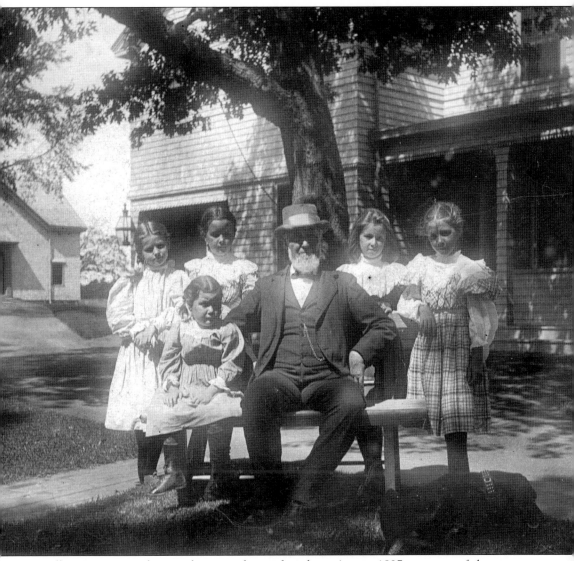

Russell Marston, seen here with some adoring friends in August 1897, was one of the most ardent champions of freedom of thought and speech. A Centerville sea captain who turned Boston restaurateur, Marston was a good friend of William Lloyd Garrison, naming his daughter after him in his honor. A staunch abolitionist even when such a stand could have been catastrophic to his social, political, and business life, his restaurants were for a number of years the only ones in Boston to serve black patrons. (Courtesy Melvina Crosby Herberger.)

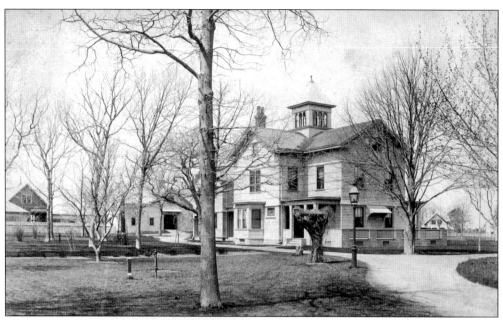

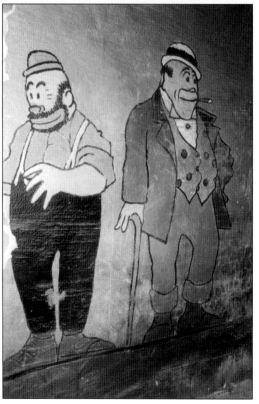

Marston's home on Main Street, which he built in 1857 and lived in until his death in 1907, became a symbol of progressive political and social views. While Marston owned it, he welcomed slaves who were in need of a safe haven during their flight north. William Lloyd Garrison, the great champion of the abolitionist movement, was a frequent guest. During Prohibition, while it was owned by Albert and Johanna Starck (the owners of Camp Opechee on Wequaquet Lake), the basement of the house became the site of a speakeasy. Mutt and Jeff murals were painted on the walls of the main room and antechamber and still enliven the secret space.

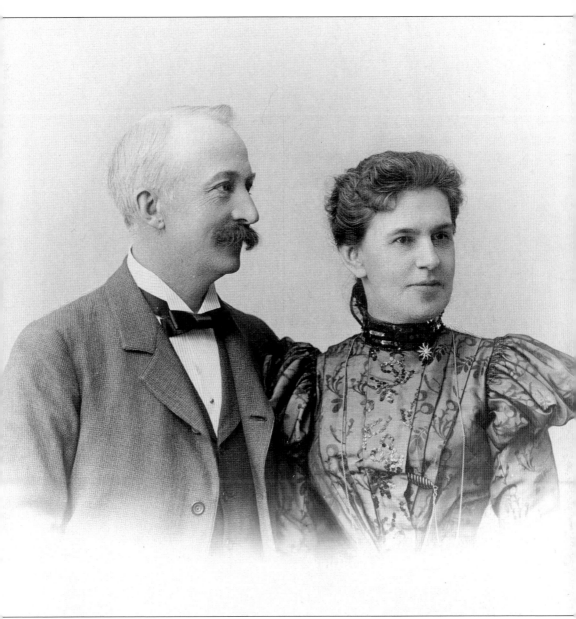

Howard Marston, an abolitionist like his father, Russell, married Ella Kelley, Ferdinand Kelley's daughter in December 1869, the day after their best friends, Augustus Ayling and Lizzie Cornish, were married. As Marston and Kelley were "come-outers," they did not marry in the church but in Russell Marston's home on Main Street. The two couples held a joint reception at Russell Marston's estate on Christmas Eve; on Christmas Day, friends accompanied the two newlywed couples to the train depot in West Barnstable, where they left for a joint honeymoon in Portland, Maine. The Marstons had one son, Shirley, who followed his father, Howard, and his grandfather Russell into the restaurant business.

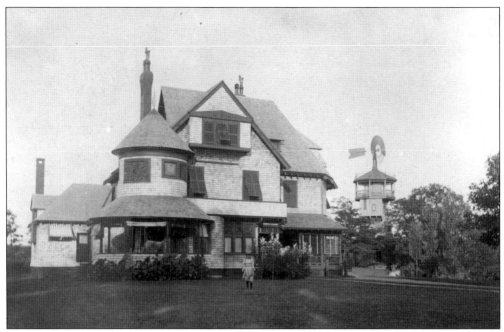

In 1881, Howard Marston built Fernbrook, a Victorian estate situated on 17 acres on Main Street. The grounds were designed by famed landscape architect Frederick Law Olmstead, who designed the "Emerald Necklace," Boston's series of public gardens, and New York's Central Park, among others. After the death of Ella Marston in 1931, Technicolor inventor Herbert Kalmus and his wife, Natalie, moved in. In 1941, when Disney's *Fantasia* opened in theaters, Herbert and Natalie Kalmus entertained a number of Hollywood celebrities there, including Walt Disney, Cecil B. deMille, and Gloria Swanson. In the 1960s, Fernbrook again switched hands when it was given over to the Carmelite Order. Cardinal Francis Spellman frequently used Fernbrook as a retreat where he hosted both John F. Kennedy and Richard Nixon.

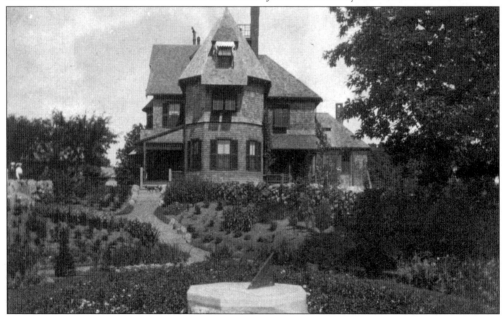

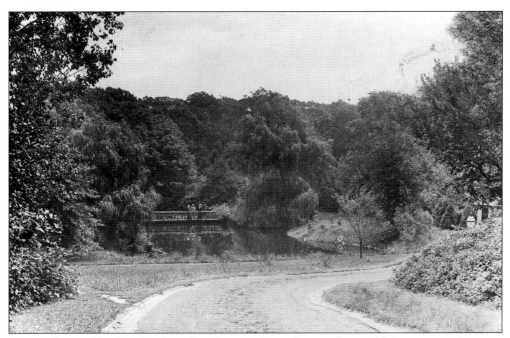

The gardens at Fernbrook, planted with trees from all over the world, incorporate Japanese sculpture, ponds, footbridges, cascading ornamentals, and a heart-shaped "sweetheart garden."

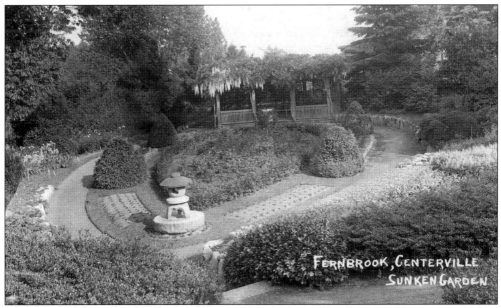

The sunken garden at Fernbrook can be best appreciated from the windmill that was built on the residence, where the grounds can be observed in their entirety. (Courtesy Vivian Nault.)

Ella Marston is seen here frolicking in her gardens at Fernbrook with girlfriends Eva Stone and Mollie Crosby.

A maternal descendant of one of the Mayflower voyagers, Charles Lincoln Ayling, was born in Centerville in 1875, the son of Civil War veteran Augustus D. Ayling and Lizzie Cornish. Ayling became a highly successful businessman, serving as director of the John Hancock Mutual Life Insurance Company for 45 years. Like many devoted Centerville residents before him, he was active in civic affairs and engaged in many philanthropic ventures. He took the lead in bringing electricity to Centerville in 1916. He was a founder of Cape Cod Hospital, was instrumental in founding the Centerville Fire Department in 1925, and provided a portion of the funds for the new village library. He also joined others in purchasing the land on which the Hyannis Airport was constructed and gifted and endowed the Centerville Historical Society.

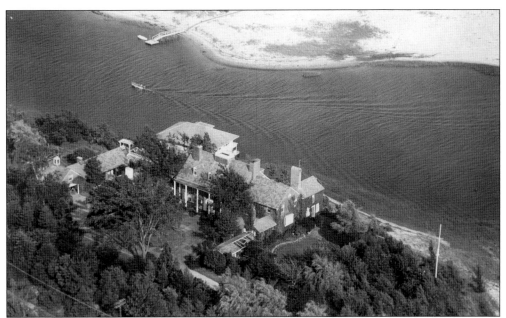

In 1921–1922, Ayling built himself an oceanside mansion of 22 rooms. Located behind the shores of Long Beach on beautifully landscaped grounds, where the Centerville River is joined by the Bumps River, this stately Georgian mansion exemplifies the types of homes that were being built in the area in the 1920s. The entrance to the estate is marked by a picturesque windmill. This home and the adjoining farm with gardener's cottage was called "Wekonee," which means "pleasant place." Ayling treasured the history of his native village. As a young man, he began collecting mementos of Centerville and Cape Cod and was one of the founders of the Centerville Club in Boston (1906). In 1963, he established the Cape Museum of History and Art, which was to open as a public museum and finally did so in a very limited fashion in 1970. Following his death in 1972, a large portion of his collection was given to the Centerville Historical Society, as well as the funds to construct an addition to house the collection, which was added on to the existing building.

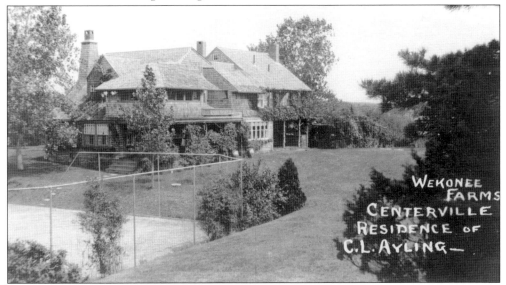

WEKONEE FARMS CENTERVILLE RESIDENCE OF C.L. AYLING

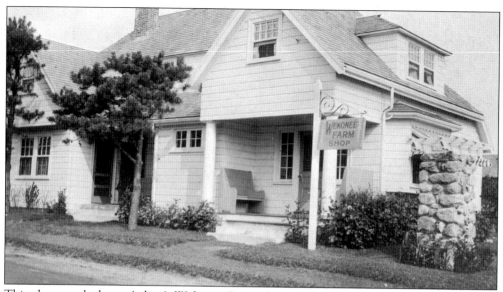

This photograph shows Ayling's Wekonee Farm Shop.

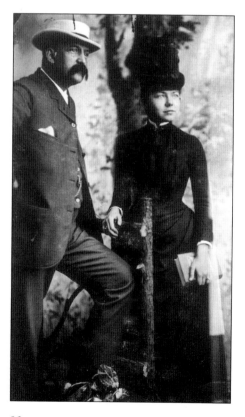

Born into a musical family, Amy Cheney Beach (1867–1944) was one of the most widely performed composers of her generation and was the first American woman to win international recognition as a composer of choral and orchestral works in the world of classical music. By the early 1890s, Beach had found critical acclaim and financial success in the United States. In 1895, she and her husband, Henry, built a summer cottage in Centerville that they called the Pines. "We wanted to live in a tent . . . and we could have stood it well enough but the piano could not, so we built a cottage around the piano." She bought an additional 11 acres of land alongside Long Pond. In the 1930s, she performed at the Centerville Association of Music and Art. (Courtesy Milne Special Collections, University of New Hampshire, Durham.)

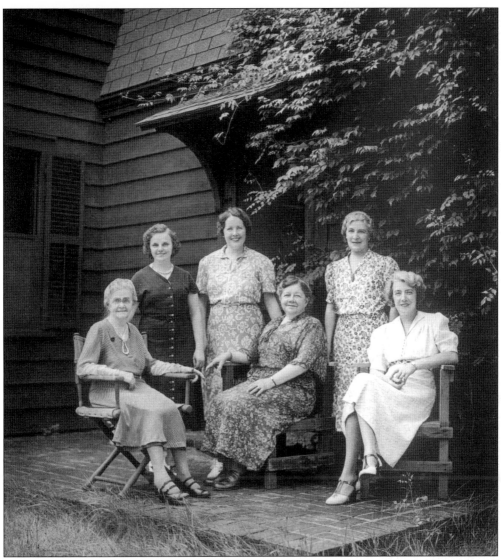

In a passage from her writings, Amy Cheney Beach reflected on one of the aspects of Centerville that was so dear to her. "To me there is no sensation comparable to the joy of feeling the ground go from under my feet when beginning a swim. . . . Why cannot I realize in exactly the same way the presence of God, resting upon Him as upon the water and feeling . . . that I cannot sink while He holds me up?" With the exception of a 13-year period from 1911 to 1924, Beach summered in Centerville every year. A one-room studio between her house and Long Pond served as her retreat to compose, correct proofs, and read. She treasured her summers in Centerville swimming in the surf at Craigville Beach, taking trips to the ice-cream store and eating in local restaurants. In her will she left the Centerville house and land to Boston's Emmanuel Church, specifying that it be used as a summer camp for poor children. A 1943 codicil, however, left the house to her friend Lillian Buxbaum, who used it as a summer home. Eventually, the property was sold and the house was demolished. Amy Cheney Beach (seated at center) is seen here in 1925 at her cottage in Centerville with her friends Fannie Lord, Eugenie Limberg, unidentified, Mabel Pierce, and Lillian Buxbaum. (Courtesy Milne Special Collections, University of New Hampshire, Durham.)

"There was no gossip at your house, just stimulating ideas about the world," wrote one resident after the death of Mary Edward Lincoln, as she contemplated what she might say to her had she had the opportunity. Lincoln, born in 1868, was the second daughter of Clark and Abigail Lincoln. She lived her entire life in the home her father built next to his tin shop on Main Street. Known to many as "Mamie," she was quite a character—she was reported to let chickens run around her parlor. Interesting and well-read, she was beloved by the children of the village. She also had a strong sense of propriety, as any woman who came of age during the Victorian period did. Knowing full well that a lady was not to be seen without her hat on, when she posed for the photographer in this picture, she ran off to get her mother's wedding-day cape and hat. The photograph gained Lincoln local celebrity, as it came to be known as "Old Spice."

Seven
CRAIGVILLE

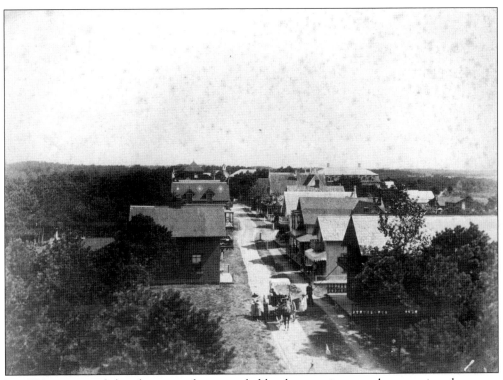

In 1871, a group of church men and women, led by the prominent and progressive clergyman Dr. J. Austin Craig, envisioned establishing a place where "the individual's spirit would be revitalized, mind challenged and body refreshed." Tasked with finding a conference site for the Christian churches of New England, Craig and his committee discovered an ideal location in the southern end of Centerville that was part of the Perry farm. They purchased a 160-acre tract of land that was known as Strawberry Hill, located between the outskirts of the village and Hyannis Port. Two hundred eighty-eight lots were sold or leased for $100 to $200. Clergy were given theirs for free. A few small shelters were built immediately, but most families erected tents on their newly purchased lots. In 1882, in memory of Dr. J. Austin Craig, Camp Christian was renamed Craigville.

On a bluff overlooking Nantucket Sound, Craigville is situated in the most bucolic of settings. To the west, the Centerville River and salt marsh is teeming with wildlife. To the east, Lake Elizabeth and Red Lily Pond is alive with ducks, geese, swans, and waterlilies. The beautiful beach and pine-covered landscape provided an ideal setting for both worship and recreation, and the Hyannis railroad made it accessible to all of New England. Separated from the main village of Centerville by the river, local residents crossed by the pullover—a ferry described as "a long boat, square at both ends, run by a rope between stakes on two shores, fitted with seats, which served as a ferry. Captain Kelley managed the board, the fare being two cents each way." (Courtesy Christian Camp Meeting Association, Craigville.)

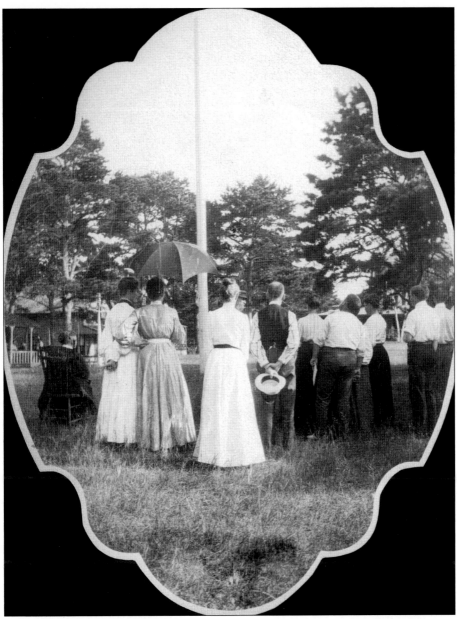

The first camp meeting was held in July 1872. More than 300 carriages clogged the roads of Cape Cod. A steam locomotive carrying carloads of delegates arrived in Hyannis. Headed for Camp Christian, they climbed aboard John Bearse's horse-drawn barge called *My Friends*. The meeting lasted 10 days and signalled the beginning of 129 years of service of the Christian Camp Meeting Association. A progressive collection of individuals, they honored the leadership of women as well as men, founded educational institutions that were coeducational as well as interracial, and established the first religious paper in America. Over the years, Craigville has become a gathering place for writers, artists, educators, and musicians. No longer a summer retreat, it has become a year-round mecca for inspiration and education, representing approximately 600 churches in Massachusetts and serving thousands of people each year of all religious and national heritages. (Courtesy Christian Camp Meeting Association, Craigville.)

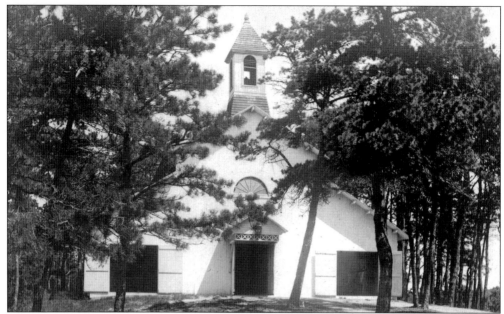

Craigville's first place of worship was a tent top stretched over a wooden frame—a rustic solution at best. After the canvas was ripped each year due to storms, it was decided to erect a more permanent structure and, in 1887, the Tabernacle, which sits on Christian Hill overlooking the village, was dedicated. Originally, the sides were left open, simulating a biblical tabernacle or tent church. The floor was sand and large kerosene lamps were fastened to support beams. In the tradition of early New England meetinghouses, the Tabernacle provided the setting for events other than worship. It was the meeting place for villagers to discuss business matters, conduct classes, and enjoy entertainment. Eventually, the building evolved from a modified tent structure into a simple wooden sanctuary, to which a bell, stained-glass windows, and redwood chancel were added. (Courtesy Christian Camp Meeting Association, Craigville.)

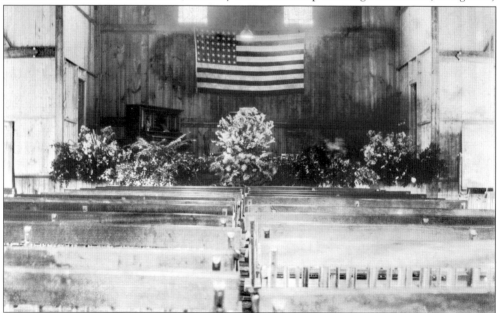

One of the many quaint and tiny cottages that line Craigville's passageways, Alpha House, with its signature architectural embellishments, is a Craigville landmark. (Courtesy Christian Camp Meeting Association, Craigville.)

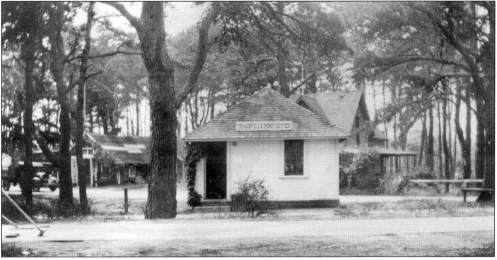

A permanent post office was established in Craigville in 1882, and it soon became a central gathering place for the villagers. In the early years, mail came from Centerville by the pullover craft, which crossed the Centerville River, and then up the foot path over Christian Hill to be deposited on the shelf near the postal window. The first postmaster, "Uncle Broad," used to hold up letters and call out the names to the waiting crowd. An accomplished violinist, he would occasionally entertain at the post office or in the parlors of the Captain Sturgis Hotel. The post office continued to serve the year-round population of Craigville until 1998. (Courtesy Christian Camp Meeting Association, Craigville.)

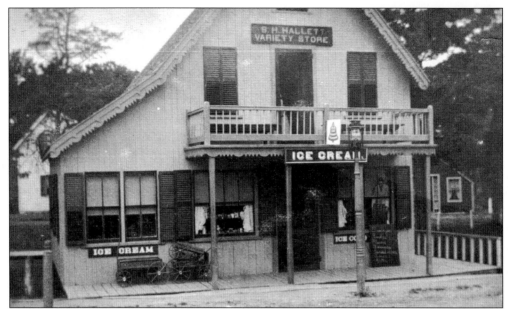

Moses Hallett, owner of a general store on Centerville's Main Street, built an offshoot of that store in Craigville in 1873. It was enlarged in 1887 and inherited by his son Sam. The store became famous for its homemade peach ice cream, penny candy, and soda pop. In addition to Hallett's store, there were tents for a barber, a stable, and one for refreshments. A blacksmith shop was built behind the Tabernacle.

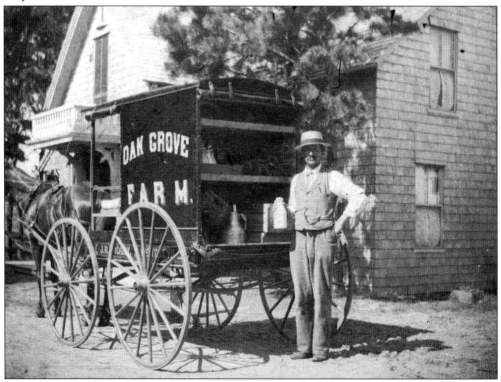

Milkman Jehiel Crosby is shown delivering goods in August 1897.

Craigville's burgeoning summer population had greatly increased traffic on the dirt roads. The bakery wagon, fish dealer, and milkman left clouds of dust, which sifted into living rooms. The cottages facing the narrow Pleasant Avenue were particularly affected. As a result, the road was closed and converted into a gravel path, which is now known as the Midway. Only foot traffic was allowed, and it provided a direct route to the bluff and the 40 steps leading to the boardwalk to the beach.

Although Craigville originated as a summer retreat, it soon took on the look of a village rather than a campground. Tents were rapidly replaced by cottages, built very close together and separated by narrow tree-lined lanes, testifying to their origins as tent platforms. These early cottages were small and spare. Often, there was not enough money for a toilet, so an outhouse was used; the only amenities were a coal stove and a washtub. Over the years, five generations have added dormers, bathrooms, fireplaces, windows, and porches. (Courtesy Christian Camp Meeting Association, Craigville.)

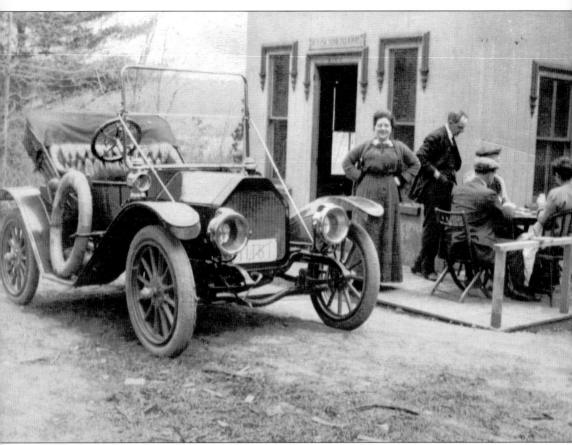

Aside from tabernacle services, life was enlivened by band concerts, crabbing parties, bacon bats, porch parties, barbecues, marshmallow roasts, cakewalking, tennis and croquet tournaments, and community singalongs. In this photograph, visitors relax with a game of cards. (Courtesy Christian Camp Meeting Association, Craigville.)

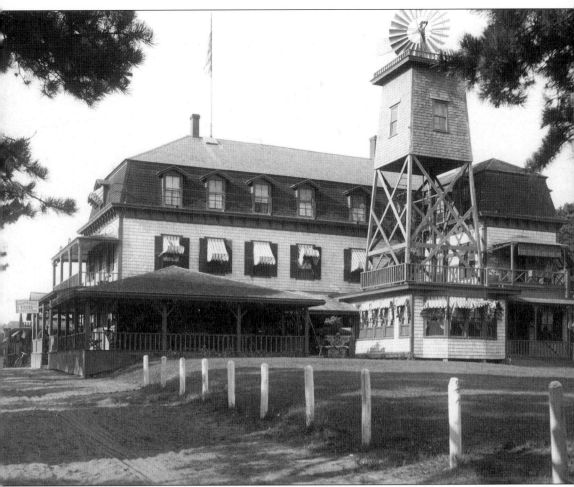

On the south end of the Green, on the present site of the volleyball court, rose the stately and imposing Watson's Hotel, built by John Watson in 1872. The impressive three-story building, which was eventually called the Chiquaquett House, had a giant windmill to pump water from its own well. Each floor had a bathroom that was shared by visitors, as rooms were not equipped with their own bathrooms. The inn became particularly popular with the younger crowd because of the dances that were offered on Wednesday and Saturday nights. In 1936, the per-person cost for a double, which included meals, ranged from $21 to $27.50. (Courtesy Christian Camp Meeting Association, Craigville.)

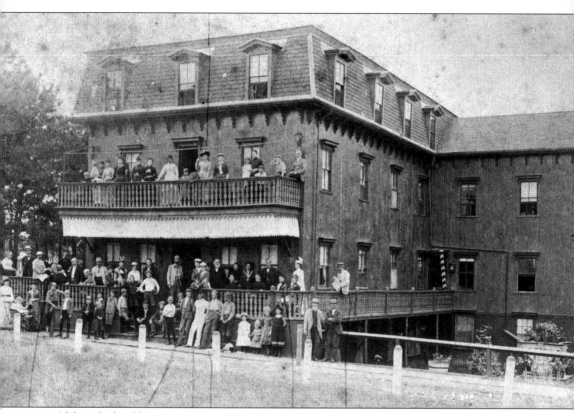

Although the Chiquaquett House was demolished in 1944, its annex, built across the street in 1872, continued to serve summer visitors for 30 years. It was first called the Captain Sturgis Hotel, after Dennis Sturgis, who ran the dining tent when Camp Christian was established. By 1875, it was called the Sabens House. It was called Ye Annex from 1891 until 1952, when it was yet again renamed to Harvard House. It was torn down in 1975, and the site is now a children's playground. (Courtesy Christian Camp Meeting Association, Craigville.)

The Craigville Inn, built by the Fall River Christian Society in 1874, stood to the east of the Green. The inn was rather primitive. Kerosene lamps were used for lighting, and there was only one bath for each floor. Each room had a chamber pot and wash stand, and partitions that did not even extend to the ceiling divided the rooms. The inn was always filled to capacity with guests who wanted the benefits of Craigville without owning a site or a cottage. Because the inn was used as the headquarters for the clergy and lay leaders, entertainment was sedate, smoking was prohibited, and card playing was frowned upon. (Courtesy Christian Camp Meeting Association, Craigville.)

Managers of the Craigville Inn made every effort to accommodate their guests and ensure that each person's stay was memorable. Then, as today, the staff was made up of primarily college students. Perhaps the best-known former waitress was the Hollywood actress Ruth Hussey. (Courtesy Christian Camp Meeting Association, Craigville.)

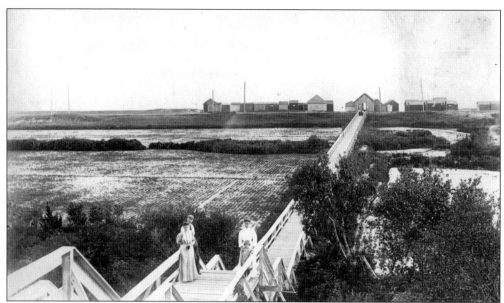

In 1881, a boardwalk was built over the bog to allow people to walk to Craigville Beach. (Courtesy Christian Camp Meeting Association, Craigville.)

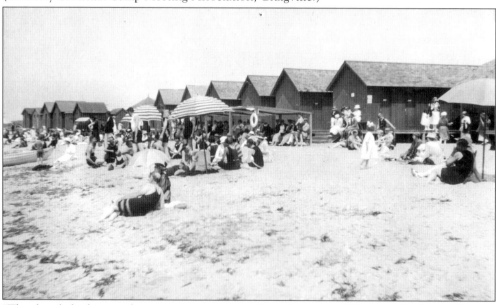

"This beach had no undertow, no current, no dependency on tide, a sandy sloping bottom and . . . the Gulf Stream keeps water temperature in the 70s," wrote a New York paper in 1921, recognizing Craigville Beach as the fourth best beach in the world. The crescent-shaped shoreline of Centerville Harbor was surely a major factor in the decision of the Camp Christian Meeting Association founders to locate their camp here. In 1888, recognizing its importance to the life of the community, the association purchased 800 feet of beach property for $850 for sun and surf bathing for its members. In 1888, a large beach house with changing facilities for members was built and the beach soon became the focus of Craigville's social life. The beach house and the rows of bathhouses built by families over the years were destroyed by the 1944 hurricane. (Courtesy Christian Camp Meeting Association, Craigville.)

Eight

HISTORIC EVENTS

In the 1890s, due to the changing economy of Centerville and Cape Cod, a number of Centerville families moved to Boston and the Midwest to earn a living. For years, most returned in the summertime, renewing bonds with friends and family. During the week of August 19–22, 1904, the Centerville community organized and held the first Old Home Week celebration. The celebration was a week of fun and games meant "to celebrate the homecoming of sons and daughters," bringing them together where they "met to renew the associations of early years." All of Main Street was decorated with Japanese lanterns strung from the tops of trees back and forth across Main Street. Banners and flags decorated houses and public buildings, and Howard Hall, the centerpiece of the festivities, was enlivened by massive bouquets of flowers.

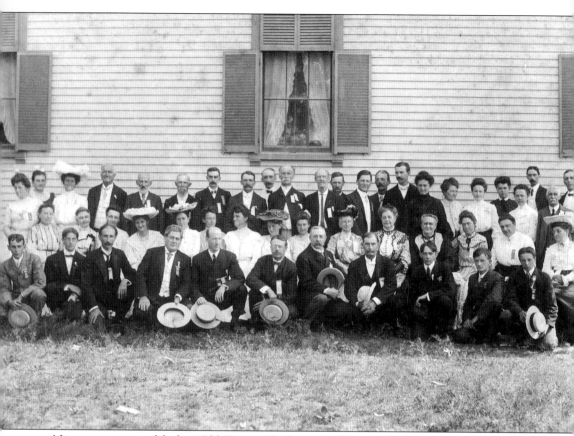

Ninety years passed before Old Home Week occurred again. In 1994, it was revived as an annual event. Each year, it brings the community together in an old-fashioned neighborhood celebration, and villagers look forward to the food, programs, and sporting events. In this group photograph, the 1904 Old Home Week Committee poses for posterity.

The listing of Saturday's events in the 1904 Old Home Week program included such show stoppers as the ladies' barrel-rolling contest and the men's rowboat race on Wequaquet Lake, in which Sam Hallett emerged the victor. In the pudding ball contest, the unmarried men beat the married ones 30-26.

The barrel-rolling contest was a highlighted event. The ladies-only race was refereed by Charles Lincoln Ayling, seen here walking briskly in the foreground. First prize was claimed by Ms. Hinckley.

107

On a brisk Saturday morning in 1902, Charles Lincoln Ayling made history when he became the first person to drive a car to Provincetown. Accompanied by a friend in his red Stanley Steamer, they took a lunch, a tire repair kit, and an extra can of gas. Although the Stanley Steamer was capable of reaching 35 mph, Ayling anticipated that at best it would do 15 mph. His estimate was accurate, as the roads were a series of wide ruts made by Cape Cod beach wagons and buggies. He recalled that they became stuck in the sand about every mile and, on uphill grades, had to push. As they had had to stop in nearly every town to get water for the car, they arrived in Provincetown at dusk. Despite their protests, the owner of the hotel at which they were staying would not let them park the car near the hotel for fear that it would blow itself to smithereens during the course of the night, taking the hotel with it. In this 1904 photograph, Ayling is seated beside his wife, Margaret.

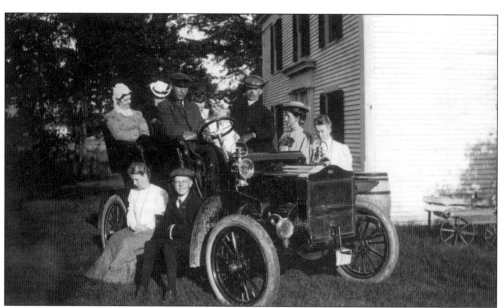

The Crosby family soon followed suit. They are seen here in their first car.

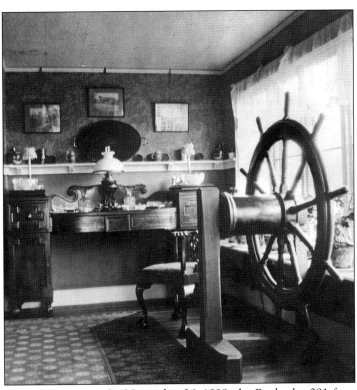

On November 26, 1898, the *Portland*, a 291-foot paddle-wheel steamer, was lost at sea during the storm while carrying about 176 passengers and crew. Despite hurricane warnings, the steamer continued on schedule, leaving Boston and heading for its home port in Portland, Maine. It was last seen off the coast of Truro, where it was completely destroyed, taking the lives of all those on board. Bodies of victims and various parts of the wreckage were picked up by the crew of the High Head Lifesaving Station in Truro over the course of several weeks. The ship's wheel, which was authenticated in a 1904 letter by Charles P. Kelly, keeper of the High Head Lifesaving Station, came into the possession of Charles Lincoln Ayling soon after. He wrote, "This wheel I obtained from one of the Coast Guard men in about 1906. . . . I went to his house [and] saw a large object in the corner of the dining room, covered with a sheet and I asked him what it was and the wife said, 'The wheel from that old Portland and I wish he would get rid of it' . . . I asked how much they wanted for it and I purchased it." The wheel, shown above when it was in the home of Ayling, eventually came to the Centerville Historical Museum through Ayling's estate.

MR. AND MRS. SWAN

AND

CYGNETS

WILL HOLD RECEPTIONS EVERY SUNDAY AFTERNOON

DURING JUNE AND JULY

TO WHICH YOU AND YOUR FRIENDS

ARE CORDIALLY INVITED

HOWARD MARSTON

CENTERVILLE 1908

In characteristic playfulness, Howard and Ella Marston, excited over the birth of cygnets on their pond in Fernbrook, invited friends to visit throughout the summer to see the newest additions to their estate. Formal invitations were drawn up and sent from "Mr. and Mrs. Swan and Cygnets." (Courtesy Melvina Crosby Herberger.)

On the evening of September 14, 1944, a hurricane hit the New England coast with winds reaching over 90 mph. The noise was horrific, and around 11 p.m. the village lost power. Luckily, most of the people in the most vulnerable locations, such as Long Beach, were evacuated, although a few had to be rescued at the height of the storm. When residents cautiously emerged from their homes the next morning, they saw their village in a state of devastation. Giant trees that had survived the 1924 storm had been split or uprooted. Monuments were lifted off their pedestals. Houses had been twisted off their foundations and carried into the Centerville River, and the debris of boats, furniture, and broken houses was scattered everywhere. The miracle was that there was no loss of life in Centerville or on the rest of Cape Cod. Immediately after the disaster, residents set to work repairing their community.

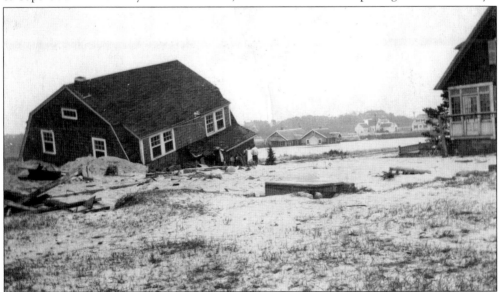

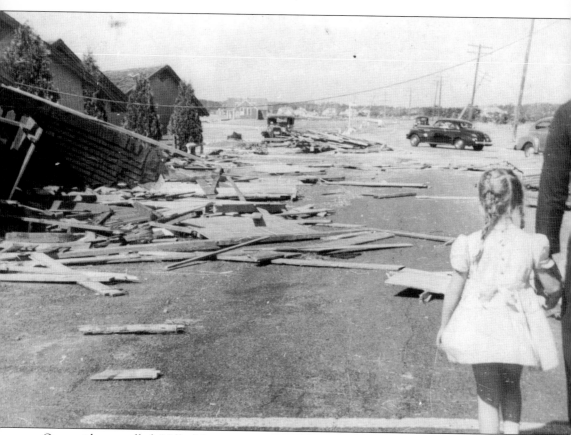

One resident recalled, "All of the structures were blown and carried like a flock of sheep to the bluff." This photograph, taken the morning after the storm, finds a serviceman and his daughter as they look upon what was once a row of bathhouses at Craigville Beach. The sands of Craigville Beach had pushed up the hill onto Craigville Beach Road, which had buckled in big sheets.

Nine
SUMMER FUN

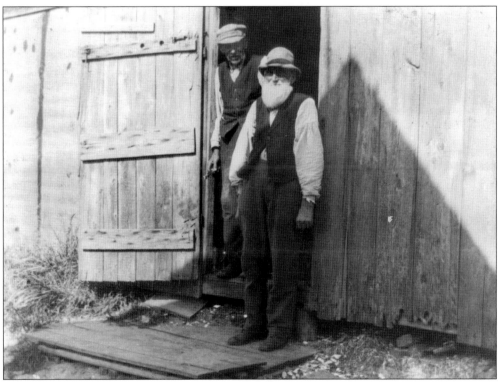

Capt. James Delap Kelley owned one of three fish shacks, located on Craigville Beach near to where the shipbuilding wharf had been located. One windy afternoon, Kelley spread a fishnet over an open window. A passing resident asked him about it, noting that it would not keep the wind out, to which he answered, "It won't keep the wind out, but it will strain it some." It was reported in a local paper that, at age 82, Kelley could still row 15 miles in a day. A skilled fisherman, he found a flourishing market for his catch with the summer crowds at Craigville.

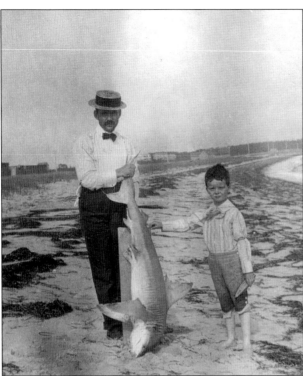

Others, while perhaps being a bit overdressed, also tried their hand at fishing. Here, Crosby family members land a five-foot shark.

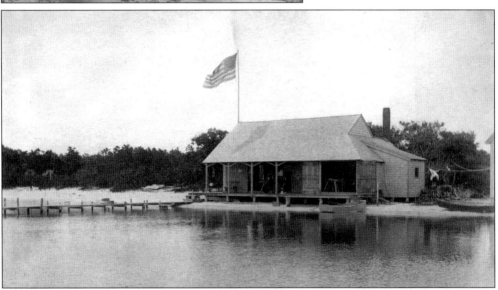

In 1875, Elisha Bearse built a series of cottages on Great Pond. This waterfront camp and nearby home offered living accommodations and dining and was particularly appealing to hunters and fishermen. The popularity of Bearse's camp reflected economic changes and attitudes in the 1880s and 1890s. Increasing economic prosperity created a leisure class that looked to vacation in the mountains and by the sea. All over New England, resort areas and mountain houses were being developed. In the late 19th century, there was an increasing desire among urban dwellers to escape the dirt and overcrowding of the cities in search of fresh air and healthful surroundings.

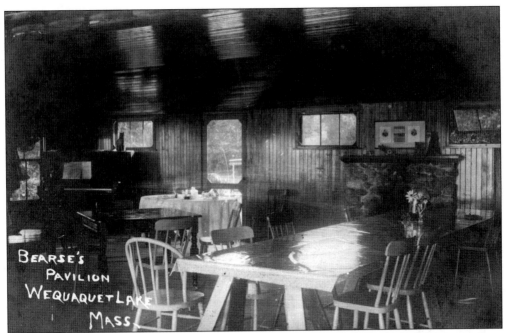

In the dining room of the camp, Elisha Bearse entertained such distinguished visitors as Pres. Grover Cleveland and actor Joseph Jefferson.

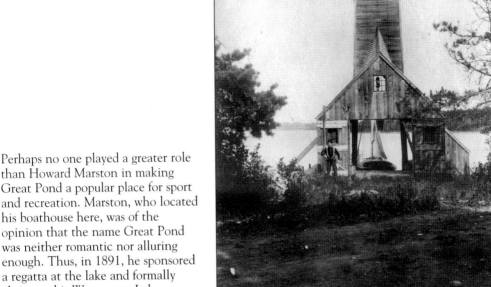

Perhaps no one played a greater role than Howard Marston in making Great Pond a popular place for sport and recreation. Marston, who located his boathouse here, was of the opinion that the name Great Pond was neither romantic nor alluring enough. Thus, in 1891, he sponsored a regatta at the lake and formally christened it Wequaquet Lake.

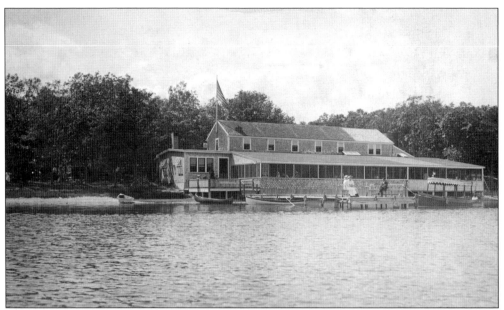

In 1903, Albert and Johanna Starck, who had once been employed by Marston Restaurants, opened a restaurant and inn on the lake. Called Camp Opechee, it was located down the shoreline from Bearse's camp. It became the favorite meeting place for the Centerville Club of Boston, which was founded in 1906 for the purpose of keeping people living in Boston with family connections in Centerville in touch with one another and the village. Every summer occasioned a nostalgic reunion. Opechee's name, which is a Native American word for robin, was taken from a line in Henry Wadsworth Longfellow's *Song of Hiawatha*. In 1907 or 1908, the Starcks moved into Russell Marston's estate on Main Street and expanded their enterprise by using it as an inn.

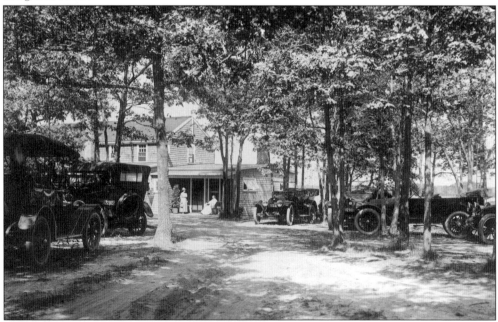

This view shows "the Grove," located behind the main building of Camp Opechee.

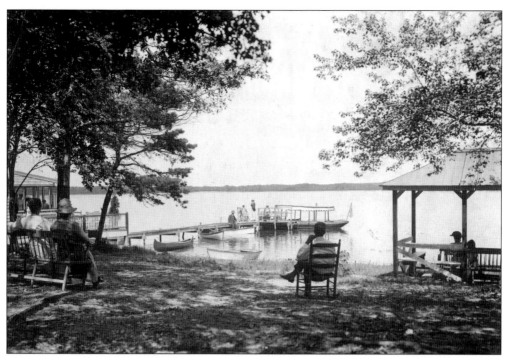

Shown in 1918 is the boat landing at Camp Opechee, Wequaquet Lake.

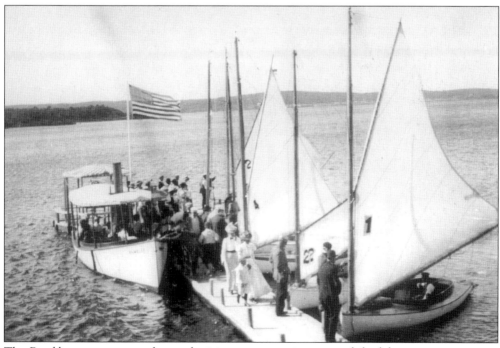

The *Rambler* was a steamer that took visitors on excursions around the lake.

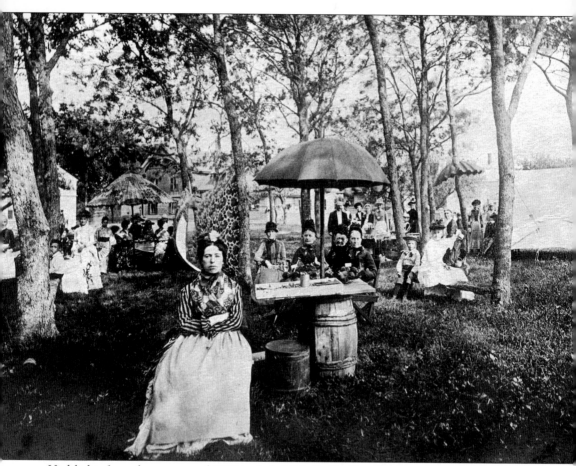

Highlights from the summer of 1880 included Ethel's Pin Fair Picnic.

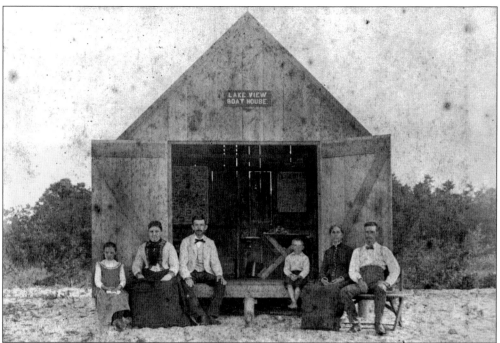

These photographs show the
Phinney boathouse and catboat on
Wequaquet Lake.

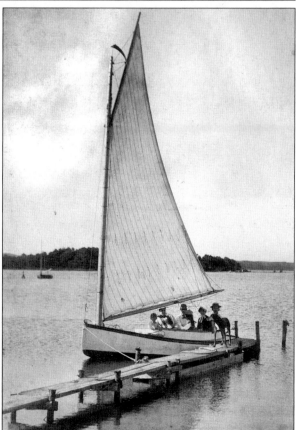

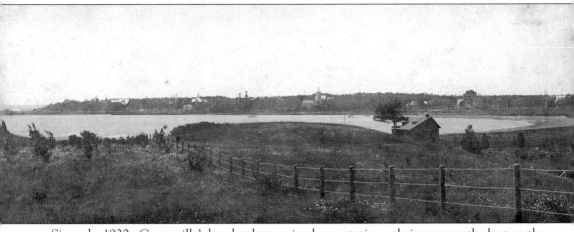

Since the 1920s, Centerville's beaches have gained a reputation as being among the best on the eastern seaboard. The fine white sands that define the two-mile long parabolic curve have beckoned visitors for decades. The east section of the long strip of beach on Nantucket Sound was named after teacher William Covell, who was the beach manager for many years. The Centerville Wharf Company operated a shipyard here in the 1850s. The central section is owned by the Christian Camp Meeting Association and is called Craigville Beach. The west section is owned by the Town of Barnstable. The Beach Club, a private club adjacent to the town beach, occupies a private strip of beach located between the town beach and Long Beach, seen here.

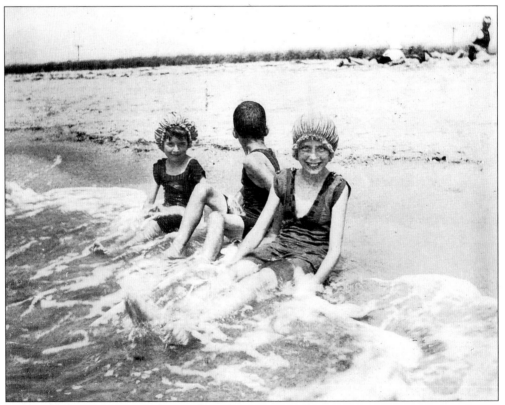

These children are enjoying the gentle surf on Long Beach.

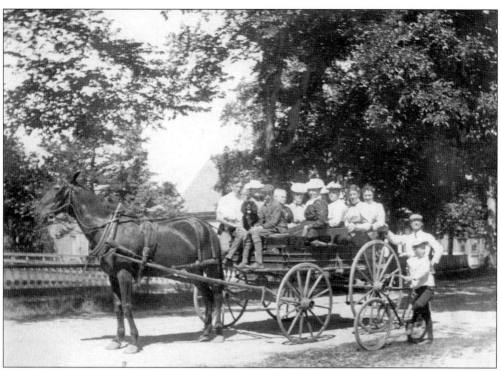

The beach barge takes early sun worshipers out to the wave-washed shore.

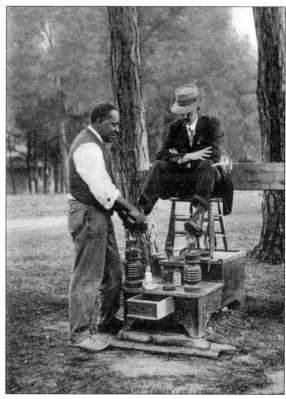

"Shine 'em up!" This 1930s postcard depicts a gentleman by the name of Ben, who offered shoeshine services to visitors to the beach.

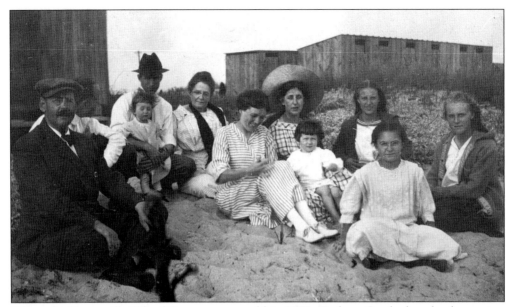

When the Centreville Wharf Company was sold in 1879, Gorham Crosby bought the section of beach that it was on for $8.50. It became the location of several fish shacks, and although Crosby did not collect rent, he did accept some free fish now and then. In the 1880s, visitors to Crosby House, Crosby's residence and inn on Main Street, began using the beach for bathing. The Crosby family owned this section of beach until 1924, when the Town of Barnstable took the property by eminent domain and established it as a public beach. Here the Crosby family is seen in front of the family bathhouse in the 1890s.

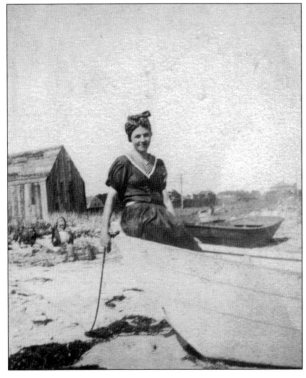

Shown here is one of the beach's many bathing beauties.

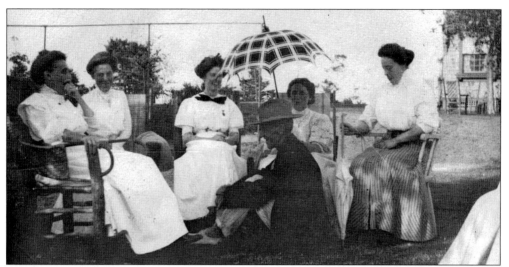

The Centerville Club was organized in Boston in 1906 with 45 charter members. These Centerville residents, who left the village for business reasons, met for their first banquet on March 6, 1906, at the Revere House in Boston, and more than 150 people attended. The membership included Augustus D. Ayling, Charles Lincoln Ayling, John B. Cornish, Howard Marston, and the Halletts, Kelleys, Crosbys, Sturgises, and Nickersons. The club encompassed three generations of villagers. John B. Cornish, who was president, welcomed the club and praised the men and women at this first gathering, stating that it was from them "from which has evolved that ideal of human character—the well-developed, full-grown American citizen." Here the club gathers at a lawn party hosted by Charles and Margaret Ayling at their estate in Centerville.

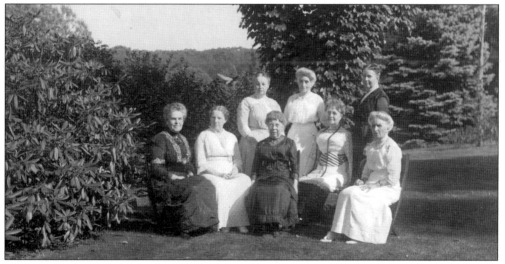

Like the Centerville Club, the Girl's Club, which formed in 1911, was a gathering of eight Centerville-born women (with the exception of one). These women, described by one newspaper article as "frolicsome," spent the winters in Boston and met at each other's homes every other week for "a simple Cape Cod supper." The object was to get together and have a good time, "reminisce about home, school days, and weddings." The group consisted of Ella Marston, Lizzie Ayling, Louisa Crosby, Susan Cornish, Olive Lockwood, Eva Stone, Melissa Hamblen, and Helen G. Woodbury.

This 1914 picture shows a group of Centerville's young mothers and their babies. From left to right are Lizzie Elliott and daughter Frances, Elizabeth Bearse and son Laurence, Eunice Crocker and daughter Margaret, Nellie Hallett and daughter Alma, Grace Whitford and daughter Geraldine, Helen Hall and son Cyril, Una Kelley and daughter Eleanor, and Julia Voss and daughter Betty.

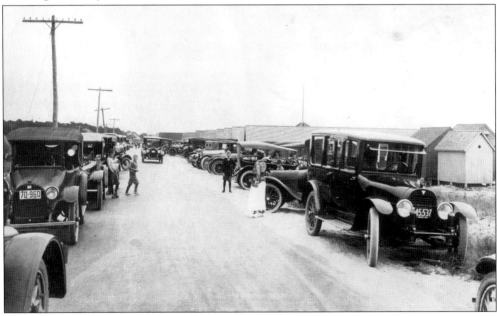

"Oh, that heavy summer traffic!" During the 1920s, the technological innovations of the automobile gave incredible access to more than just the elite. During this period, Centerville went through its first major building boom and the make-up of Centerville's summer visitors changed as well. Prior to the 1920s, most of the visitors had close connections with Centerville, as they were either original residents themselves or they had immediate family living in the village. After 1920, attracted by the desirability of the location and the far-reaching reputation that Craigville Beach had as one of the best on the eastern seaboard, the tourism industry emerged and visitors no longer reflected that hometown connectedness.

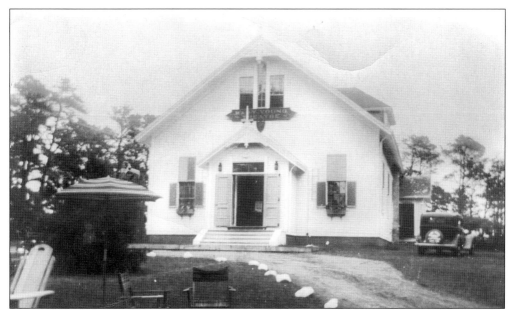

Part of the draw for tourists was summer theater, which had its beginnings on Cape Cod. It was only natural that a theater company started up in Centerville as an attraction for the summer influx of vacationers. In 1936 and 1937, under the direction of Mary Young and her son John Craig of Boston, Howard Hall was transformed into the Mary Young Theater, where theatrical productions were hosted throughout the summer. Productions included Gilbert & Sullivan's *Trial by Jury*, *H.M.S. Pinafore*, and *The Gondoliers*. While Mary and her son lived in a small cottage on Main Street, actors and actresses boarded at the Theodore Crosby House, on South Main Street heading toward Long Beach.

Putting on their own brand of theatrical performance, Ethel Woodbury (left), an unidentified girl, and Marie Hall (right) dressed up for this rather playful photograph in 1888.

A carriage ride down the village's picturesque lanes on a summer afternoon was a favorite pastime. In this 1888 photograph, Ethel and Marston Woodbury, with dog Marco and pony Merrylegs, seem to have been exhausted by their little excursion. (Courtesy Vivian Nault.)

In 1926, 10 men and women raised $100,000 and established the Beach Club, located on a private strip of beach between Craigville Beach and Long Beach. The beach property was bought from Chester Bearse, son of Capt. Nelson Bearse, and the house on the site was enlarged to accommodate a clubhouse. The parking lot across from the Beach Club was built on a filled-in pond and marsh.

This view shows the interior of the Beach Club.

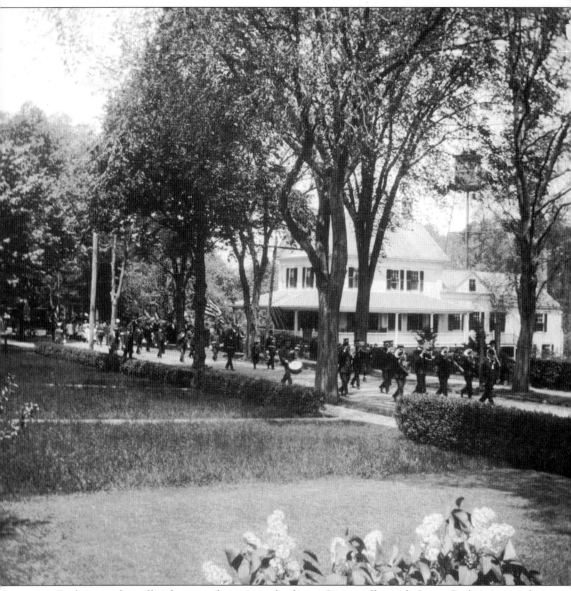

Each year the official start of summer, both in Centerville and Cape Cod in general, is Memorial Day. For nearly a century, Centerville's Memorial Day parade down Main Street, with stops at Beechwood Cemetery and Monument Square, has brought villagers together.